Doug Box's

AVAILABLE LIGHT

PHOTOGRAPHY

■ Techniques for Digital Photographers

Amherst Media, Inc. ■ Buffalo, NY

DEDICATION

My family has provided support and relief throughout my career. This book is dedicated to my wife, whom I love very much, and to my three sons and their families who, over the years, have posed for me more times than they cared to.

Published by:
Amherst Media, Inc.
P.O. Box 586
Buffalo, N.Y. 14226
Fax: 716-874-4508
www.AmherstMedia.com

Publisher: Craig Alesse
Senior Editor/Production Manager: Michelle Perkins
Assistant Editor: Barbara A. Lynch-Johnt
Editorial assistance provided by Chris Gallant, Sally Jarzab, and John S. Loder.

ISBN-13: 978-1-60895-471-1
Library of Congress Control Number: 2011942797
Printed in the United States of America.
10 9 8 7 6 5 4 3 2 1

CONTENTS

ABOUT THE AUTHOR

Doug Box has been a professional portrait and wedding photographer since 1974. He has owned three studios in Texas and has produced images in various genres—including portraiture, weddings, little league photography, commercial photography, pet photography, close-up photography, children's photography, and equestrian and rodeo photography. He has photographed subjects in a wide range of venues, including in-home sessions, outdoor and location sessions, studio photography, and even photography at a funeral.

In 1977, Doug and a couple of friends started the Brenham Camera Club, and he began teaching hobbyist photographers. He conducted seminars for community education, at country clubs, and was on a local TV station as the resident expert. Since then, he has spoken at photo conventions and seminars in forty-nine states in the U.S. He also taught in Canada, Mexico, Scotland, Wales, England, China, Ireland, Denmark, and on five cruise ships. He was chosen to teach at the International Wedding Institute for four years and has taught at eighteen different Professional Photographers of America (PPA) Affiliate week-long schools. He is only the fourth person in the association's history to earn over 1000 PPA Merits. Plus, he is a member of the prestigious CameraCraftsmen of America group. He is the past president of Texas Professional Photographers Association (TPPA) and is currently the group's executive director. He has served as executive director of the American Society of Photographers (ASP) and published *ASP Magazine* for three-and-a-half years. Doug was chairman of the PPA Affiliate Managers Group and vice chairman of the PPA Portrait Group. He served on the membership, affiliate, and chapters committee, was vice chairman of the ANNE committee, has been an officer of the local guild, and served on the PPA board.

Doug is the owner of Texas Photographic Workshops, an internationally recognized educa-

Author photo courtesy of Oscar Lozoya.

tional facility. Along with his wife LaVelda, he hosts photographers from around the country and teaches all levels of photography.

Doug is also an accomplished author. His articles and images have appeared in the pages of most professional photographic publications, and he has been featured in *Redbook* magazine twice. He is the author of *The Power of Business* marketing systems. He has written several books, including *Doug Box's Flash Photography, Doug Box's Guide to Posing,* and *Professional Secrets for Photographing Children* (2nd ed.), all of which were published by Amherst Media.

For more information on Doug, go to www.dougbox.com.

ACKNOWLEDGMENTS

This book would not be what it is without the help of every photographer, teacher, and lecturer I have had the pleasure to study with—or every student whom I have had the opportunity to interact with. The people in the former category gave me a shoulder to lean on, and those in the latter group made me a better teacher.

I'd like to thank Randy Kerr and Tony L. Corbell—my partners in World Photographic—in particular. Together, we are beginning a great adventure in teaching photography. WorldPhotographic.org is dedicated to educating individuals and photographic communities in the craft of photography while exposing their audience to global ecological and humanitarian issues that affect all members of the human population, both in our own backyard and worldwide. Our careers in this wonderful industry have ebbed and flowed for more than twenty years. We have crossed paths, worked together, and admired each other's work—sometimes without even knowing who it belonged to. We know that everything each of us has done up to this day prepared us and brought us together in this journey.

In each of my books, I write "Never stop learning!" I follow that advice to this day, and I hope you will too.

ABOUT THE CONTRIBUTORS

Tony L. Corbell, Randy Kerr, and I are partners in WorldPhotographic, which is why I asked them to contribute to this book. Their style and dedication to photography are the reasons why we first became friends. I have known Randy for over sixteen years and Tony for over twenty-five years. They are my photo buddies. Every photographer needs photo buddies who will challenge them and keep them on track. (For more information on WorldPhotographic, and to learn why you should join our ranks, go to www.worldphotographic.org.)

The three of us have a deep love for our craft. Collectively, we have photographed tens of thousands of people and have taught just as many. Some of the best images we have created tell a story; in fact, telling a story is our goal for each of our images. Whether we aim to tell the story of a bride's wedding day, capture the personality of a five-year-old child, or tell the story of a landscape affected by the elements on a stormy day, speaking to viewers through our imagery is what photographers do best. When we came together to form World Photographic, we made it our goal to teach anyone who has a camera and loves creating images to become a better storyteller. Our mission statement includes these words:

WorldPhotographic.org is dedicated to educating photographic communities and individuals in the craft of photography while exposing their audience to global ecological and humanitarian issues that affect all members of the human population.

In my thirty-five year career as a portrait photography instructor, I have come to recognize that everyone loves nature and the outdoors. I love to create a photo of a beautiful sunset just as much as I enjoy creating a touching family portrait. As a World Photographic mentor, I want to teach people to be aware of their environment as they photograph. When we photograph a child in the middle of a field of bluebonnets, we want people to realize that the flowers are a source of food for the pollinators.

As a World Photographic artist, I am working with Randy and Tony to tell the story of rebuilding libraries in the Caribbean with the Peace Corps and Hands Across the Water, as well as a photographic project called Shedding Light on Hunger in America. We feel that using our photographic and storytelling skills will help us bring awareness to the lives, experiences, and needs of people everywhere.

If you are interested in joining our team, visit www.WorldPhotographic.org. Watch for a World Photographic seminar in a studio near you.

RANDY KERR

Randy Kerr has been a professional photographer since 1979 and has created images in twenty-seven countries. He has photographed state, national, and global politicians and public servants as well as Lady Bird Johnson, Laura Bush, Willie Nelson, Clint Black, Bob Bullock, and several Texas governors. He has done work for The History Channel, Time Warner, Dell Computers, Samsung, the Texas State Museum, and more. Randy is the host of lightcamp.tv and the owner of Bastrop County Project, located in Smithville, Texas. He is also the director of education for the Smithville Music and Film Commission. Randy was invited to teach his global award-winning Westway Method of photography for five years by The Ladybird Johnson Wildflower Center in Austin, Texas. Randy's focus is to educate filmmakers and photographers on how to achieve quality light in image capture, while exposing meaningful humanitarian topics and the environmental necessity of green living. (Contributor photo by Doug Box.)

TONY L. CORBELL

Tony L. Corbell has been very fortunate throughout his career. Since 1979, he has photographed three U.S. presidents, 185 world leaders, 65 Nigerian heads of state, about 600 brides and grooms, a couple of NASA astronauts, and lots of famous and not-so-famous faces. He has spoken at almost 400 seminars and workshops nationally and internationally and is the recipient of Wedding and Portrait Photographers International's (WPPI) highest achievement—the Lifetime Achievement Award. Tony also achieved the status of Photographic Craftsman from the Professional Photographers of America. In 2005, Tony received the Photographer of the Year Award from the International Photographic Council of the United Nations at a ceremony in New York at the U.N. That year, he was also presented with the PPA National Award from the Professional Photographers of California. Tony was also invited to join the prestigious CameraCraftsmen of America in 2007; he is one of only forty members worldwide. In 2007/08, Tony spoke to over 7,500 photographers in thirty-six cities including London, Glasgow, Dublin, Toronto, Mexico City, Sydney, and many U.S. cities. He has always been active as a student and a teacher of photographic education. His book *Basic Studio Lighting* (AmPhoto Books, 2001) has been popular worldwide and has been the basis for numerous photographic college lighting courses. He has written articles in every major photographic magazine in the United States, Japan, the United Kingdom, and China. He is currently one of PPA's select few Approved Photographic Instructors. He also happens to be the biggest Beatles fan alive. (Contributor photo by Bobbie Lane.)

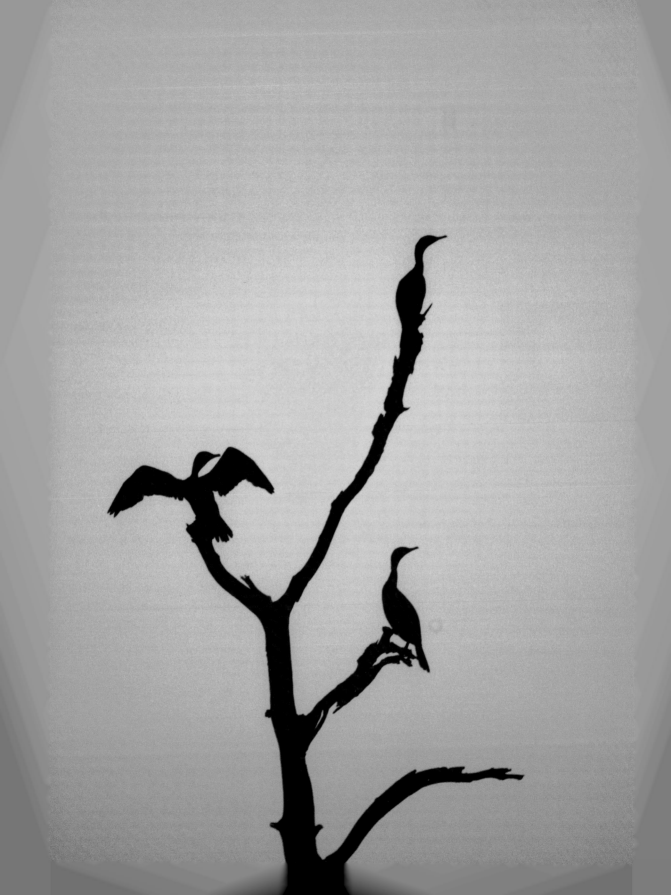

WHAT IS AVAILABLE LIGHT?

Available light is the light that is there waiting for you at a scene. It may or may not be natural light. For example, when you walk outdoors, the light that awaits you is available light. When you walk into a room and there is a lamp on, that is also available light.

WORKING WITH AVAILABLE LIGHT

In part 1 of this book, you will learn some lighting and exposure basics that you will need to fully understand in order to ensure a successful shoot anytime, anywhere. We'll cover many important topics, including how to identify good available light and use it *as is* to make great photos; how to modify or block available light with reflectors, translucent scrims, black flats, and overhead blocks; and even how to know when it is time to augment the available light with flash. You will see a host of professional images made indoors and out, in a wide range of lighting conditions. You'll also find several setup shots that allow you to better conceptualize just how a specific image was created.

In part 2 of the book, you will take a more in-depth look at images made under specific conditions, including window light, direct sun, open shade, and more. Here, you will learn how the theories and concepts outlined in part 1 can be used on location.

Learning how to control and use available light will allow you to work outside of your studio, with confidence.

Let's get started.

Facing page—Composition is key in every image. I wanted a simple background for this image. With my initial camera position, there were some branches from other trees in the scene, so I re-framed the shot. The bottom crop point of the image was deliberately chosen. I wanted to include the bottom branch and where it attached to the trunk. I placed the subject low in the frame to give space for the birds to fly into. Place a couple of pieces of paper over the image and try different croppings. Note how the image changes.

I waited until the three birds were all doing something different or positioning their bodies in different ways but looking the same direction. I like this shot with three birds. Cover up one of the birds and see how the composition changes. Image a fourth bird on the bottom branch. It would change the feeling.

I boosted the saturation a bit in the final image to enhance the color of the sky. I felt that the sillouhute worked perfectly for this subject.

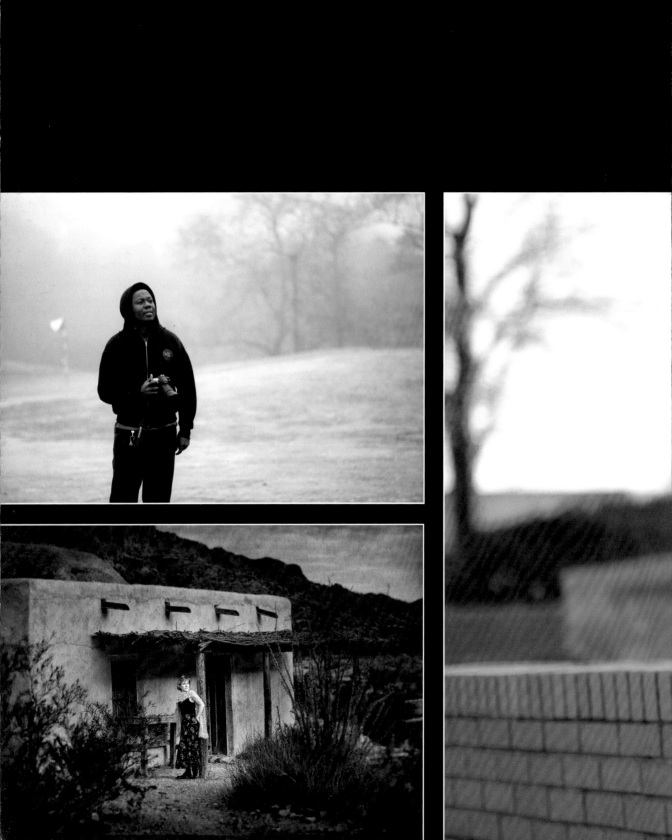

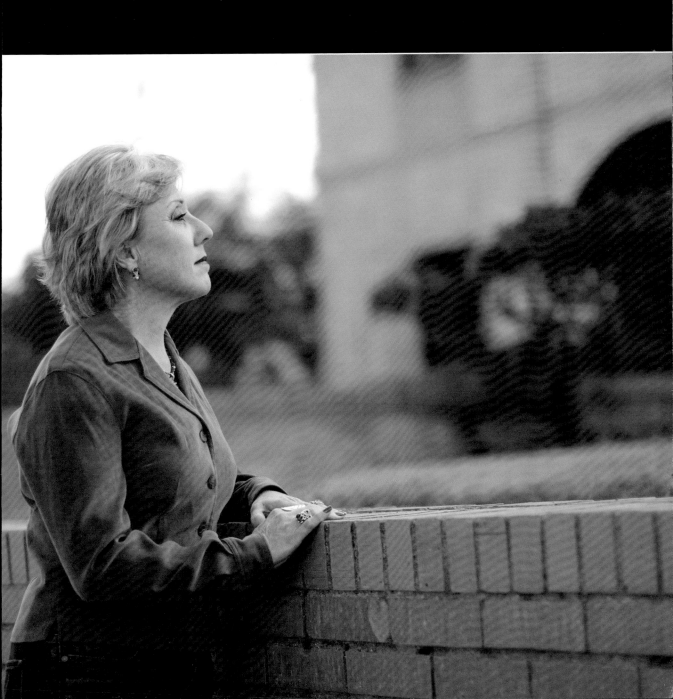

ABOUT LIGHT

HARD OR SOFT LIGHT?

When we work with light, we describe it as hard or soft. Hard light produces sharp, defined shadows. Soft light produces lighter, gentler shadows and lower contrast levels.

One way to determine the hardness or softness of light is by looking at the edge acutance (*i.e.,* the area where the light transitions to shadow). When this transition happens abruptly, the light is characterized as hard. When the transition from light to shadow is more gradual, the light is described as soft.

The size of the light source in relation to the subject and the light-to-subject distance determine whether hard or soft light is produced. For instance, the sun and a small bare lightbulb positioned far from your subject will produce hard light. When the sun's rays are scatted by thin white clouds, the sky becomes a virtual softbox, and your subject is bathed in soft, diffused light. Likewise, when a bare bulb is fitted with a light-diffusing modifier, be it a lamp shade on a table lamp or a photographic accessory like a softbox, the light's rays are scattered and made softer.

The type of light you choose to work with will depend on your subject and artistic vision.

Facing page—Some of my favorite images are were made when the weather is changing. This image was shot in color. I used NIK Silver Efex Pro 2 to convert it to black & white.

FALLOFF

Light is energy that flows like a current. It flows from the lightest areas to the darkest areas. And like any energy, it has a certain power, which diminishes as it flows. When it comes to photographic lighting, we refer to this tendency as falloff. You can see and even feel this happen. Hold your hand close to an incandescent lightbulb. You can see the brightness and feel the bulb's heat. Now slowly move your hand away from the bulb. The brightness of the light is not as intense, and the heat becomes less intense as well.

Science offers a formula that allows us to calculate falloff. It is called the Inverse Square Law. The formula states that the intensity of illumination is proportional to the inverse square of the distance from the light source. In other words, when the distance between the light and subject is doubled, the light is $\frac{1}{4}$ as bright. When the light-to-subject distance is halved, the light falling on the subject will be 4x brighter. Here's a helpful analogy: light is like me running—I start off strong but quickly run out of steam the farther I get from the starting block!

LIGHT PRESENTATION AREAS

When light strikes a subject, it can be presented as: (1) a diffused highlight area (this is the area in which the light does not affect the color or brightness of the subject, so its "real color" is apparent); (2) a shadow area (an area that is not

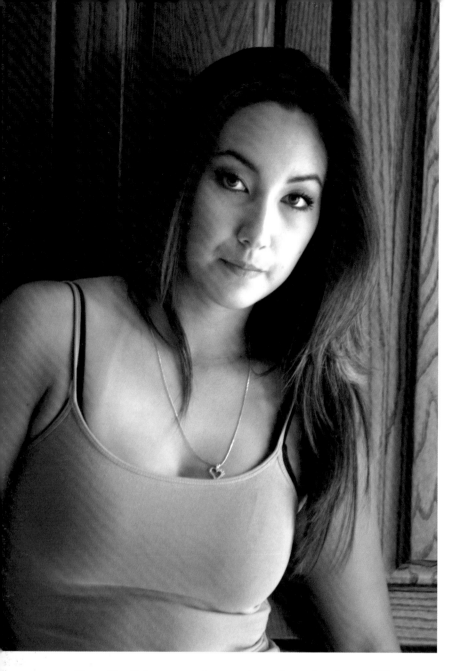

Left—Can you clearly see all four light presentation areas on this subject's face? Was the light created by a large or small light source? Where are the specular highlights? (Look at the bridge of the nose, the catchlights in her eyes, and the necklace.) As we delve deeper into using available light in our photographs, we will learn how to control, change, manipulate, and even create these different light presentation areas. The exposure was f/3.3, $\frac{1}{30}$ second, and ISO 100. The focal length was 200mm. **Facing page**—This image was made in direct sun. Notice the extreme contrast in the image and the hard edge acutance (the area where the diffused highlight transitions to shadow). The photographer positioned the subject in the dark area so he would stand out. Photo by Randy Kerr.

affected by light or one that receives a lower level of light than the diffused highlight area does); (3) the edge acutance area (again, this is where the highlight-to-shadow transition takes place); and (4) the specular highlight (a very bright area; actually, the reflection of the light source shown on the subject's surface [e.g., catchlights in the eyes or a bright area on shiny skin]).

We can even measure the intensity of the light that is reflected in these four presentation areas. The difference in brightness between the diffused highlight and the shadow is called the light ratio.

CONTRAST, CONTRAST, CONTRAST
BY TONY L. CORBELL

In the world of professional portrait photography, there have always been discussions about the highlight to shadow ratio that often defines the dimension, shape, form, and even texture in a photograph. Everyone I know has been involved in these discussions, and they generally end up agreeing that a 3:1 ratio is a good choice for a traditional portrait. This is a generally accepted standard, but it is certainly not a rule that *must* be followed.

Here, I want to discuss the other areas of contrast that we don't often talk about: scene contrast, subject contrast, and light contrast. As photographers, we are basically contrast controllers. Understanding that fact will help us to make the kinds of pictures that will set us apart from the rest of the pack.

SCENE CONTRAST

As digital photographers, we've all been faced with issues of clipped highlights and/or blocked shadows. It is often the limitations of technology that causes the problem. However, it can also be due to the contrast present in the scene we are attempting to photograph. The human eye can detect approximately twenty to twenty-one different stops of light. Modern digital cameras can detect eight, ten, or twelve stops of light. Unfortunately, the photographic papers we work with only hold detail in highlights and shadows across about four or five stops of light. Because

of this, we have to go into each session knowing where the brightest highlight and the darkest shadow will fall. By making sure the scene contrast ranges no more than four to five stops, we can ensure our images will print beautifully with detail throughout.

SUBJECT CONTRAST

Young children learn how to draw balloons in art class. They know that in order to draw a proper balloon, you draw a circle, maybe add a string, and then draw a highlight on one side (usually in white) and a shadow on the other side (in black or another dark color). This ensures the balloon has an appearance of depth and looks realistic. As portrait photographers, we have been taught to use traditional lighting pattens on our subject's face. These patterns are terrific to know and understand, but they only tell half of a story. The names of these patterns—loop, Rembrandt (or modified loop), butterfly (or Paramount), and split lighting—all describe the shadow on the cheek or lip that is created as the light crosses the subject's nose. These shadows are very helpful for establishing shape and texture on a light-skinned face. However, when photographing someone with very dark skin, the rules change. We must work in the range of light areas, not dark areas, in order to produce the contrast necessary to give viewers usable information about the subject. Think about it this way: if I were

to photograph a set of billiard balls, the shadow on the cue ball would create the appearance of depth, shape, and form. When I photographed an 8 ball, however, it would be the highlights—not the shadows—that defined the ball's form. Obviously, the contrast we place on a specific subject is directly related to the tonality of the subject. As working professionals, we need to understand this basic concept.

LIGHT CONTRAST

The size of a given light source always depends on the light-to-subject distance. However, you can reduce the contrast of any given source by changing the light from raw and sharp to soft and diffused.

Light contrast is another control that we can keep in mind as we approach a session. A friend of mine is a big fan of adding small incandescent lights to photograph a bride outdoors late in the day. This light can be slightly diffused; yes, you'll see a slight loss of light overall, but the effect on the bride's face will make you a hero.

CONTROL

I tend to speak a lot about control in my workshops. By simply keeping a few of these techniques in mind, we have a few more tools we can use on a shoot—and being in control is what it's all about.

Photo by Tony L. Corbell.

THE MAIN LIGHT AND FILL LIGHT

When more than one light is used to create a photograph, one light is usually brighter than the other. The more intense light, regardless of its source, is referred to as the main light (sometimes called the key light). In the studio, the main light is usually positioned to one side of the subject and at a 20 to 45 degree angle to the face. It is used to light the mask of the face (the forehead, eyes, nose, cheeks, mouth, and chin). Outdoors, the main light comes directly from the sun, the sunlight bouncing around the sky or reflecting off of other objects in the scene.

A fill light is a secondary light source. It is less intense in nature and is nondirectional. It is used to lighten shadow areas, reducing the overall contrast from shadow to highlight. In the studio, a

The more intense light, regardless of its source, is referred to as the main light.

This image shows a 2:1 light ratio.

3:1 Portrait Lighting Ratio

Fill light only:

f/8 = 1st unit of light on entire face.

Main light only:

f/11 = 2nd and 3rd units of light on highlight side.

Main light and fill light:

f/16 = 3 units on highlight side, 1 unit on shadow side.

Expose with camera aperture at f/16.

4:1 Portrait Lighting Ratio

Fill light only:

f/8 = 1st unit of light on entire face.

Main light only:

f/16 = 2nd, 3rd, and 4th units of light on highlight side.

Main light and fill light:

f/22 = 4 units on highlight side, 1 unit on shadow side.

Expose with camera aperture at f/22.

Note: For each setup, the fill and main lights must be metered with all other lights off.

photographer may use a reflector to bounce light onto the shadow side of the subject. Outdoors, the fill may come from ambient light bouncing off of natural or manmade objects in the scene—be it the subject's white shirt or a light-colored building.

LIGHT RATIOS

A light ratio is a mathematical representation of the highlight side of a subject (illuminated by the main light) and the shadow side of the subject (illuminated by a fill light).

Let's consider how different lighting ratios would affect the face of a portrait subject.

A 1:1 ratio implies flat lighting, where the entire face reflects the same amount of light. Flat lighting is not flattering to most subjects.

A 2:1 ratio is achieved when the mask of the face is one stop brighter than the shadow side of the face. With two lights, this is achieved by flatly illuminating the entire face with a fill light

positioned at the camera or following the nose. If the fill light reads f/8 and we add a main light, which also reads f/8, to light the mask of the face, the highlight area of the face will have two units of light and the shadow side will have just one unit—hence a 2:1 ratio!

A 3:1 ratio means that the mask of the face is two stops brighter than the shadow side. With two lights, this is achieved by first establishing a fill light (at f/8) that flatly illuminates the entire face and comes from the camera or in between the camera and main light. We will call this one unit of light. If we brought in the main light, metered at f/11 (twice as much light as f/8), we would be adding two units of light to the mask of the face. Therefore, the mask of the face would receive three units of light, and the shadow side of the face would receive just one unit of light from the fill—hence a 3:1 ratio!

The higher the light ratio, the greater the contrast range and the more dramatically the subject

Here are two different portrait versions, both made in a great spot. In the first image (top), the subject had her face turned toward the camera and away from the light. Notice that the light on the top of her head is brighter than the light on her face. For the second image (bottom), I simply moved the child back toward the building, under a small porch, and turned her face toward the open sky (light source). Both images are really cute, but the light on the girl's face is much better in the second portrait. The exposure was f/4.8 at $\frac{1}{30}$ second and ISO 80. The focal length was 200mm.

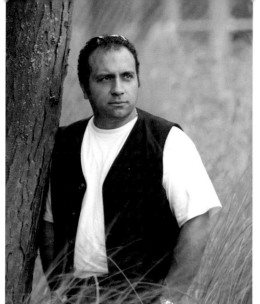 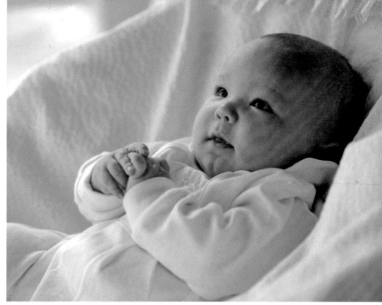

Left—Here, we have beautiful, soft light coming from the right direction—not from the top, but from about a 45-degree angle to the face—and lighting the mask of the face (forehead, both eyes, the cheeks, nose, mouth, and chin). Notice the catchlights (the specular highlights in the subject's eyes) are at about the 2 o'clock position. I usually prefer the 2 or 10 o'clock position for the catchlights. **Right**—Here is an example of good—but not great—window light. There is light on the mask of the subject's face and a soft edge acutance, but the angle the light came from was a little low—note that the catchlight is at the 9 o'clock position rather than the 10 or 2 o'clock position that I prefer. As you can see, I lit the bottom of the nose, but the nose shadow did not extend down toward the mouth like I wanted it to; instead, it extended up toward the boy's eye. That being said, I still love the portrait of this little guy!

is rendered. A 4:1 ratio is considered fairly dramatic, and a 1:1 ratio (flat lighting) is generally considered dull.

FINDING GOOD LIGHT

When it comes to portraiture, I describe "good light" as light that illuminates the mask of the face, is of good color, and is diffuse enough to give us a nice, soft edge acutance.

When I first started taking photographs with my Kodak Brownie Hawkeye as a child, I never thought about light. My dad was an amateur photographer and he taught me about lighting, but it wasn't until I started to shoot portraits that it became important to me. I realized that some of the portraits I took turned out great, but a lot didn't—and it all came down to the lighting.

So, how do you find great light?

The Light Finder. It can take years to learn how to find good light for portraits. Fortunately, a light finder can help you more easily determine whether the light you are presented with is too contrasty to create a flattering portrait.

You can easily construct your own light finder. Simply buy a 1x1x1 inch wooded block at a craft store and attach a wooden handle. Next, paint two sides (opposite each other) with the lighter shade of gray and the other two sides with the darker gray. *(Note:* Take this book or a color copy of the page to a paint store and have them make sample-sized cans of paint in the shades shown on this page.) To make the device look more professional, paint the top, bottom, and handle black. If you're not up to the task of making your own light finder, you can purchase a commerically made unit that comes with a video that will teach you how it is used. For more information, visit my web site at www.dougbox.com/shop/.

To use the light finder, turn one of the tool's darker sides toward your light source with the

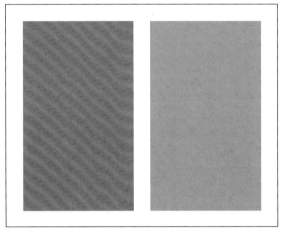

Left—Here are the two shades you should use when you create a light finder. Take this book or a color copy of this page to a paint store, have the technician scan the colors, then purchase a sample-size can of each shade. **Below**—Here, we have beautiful light on the bride, but the light is not as good on the groom. (We all know the bride is the important one!) The exposure was f/7.1 at 1/8 second and ISO 400. The focal length was 120mm. Due to the slow shutter speed, I used a tripod.

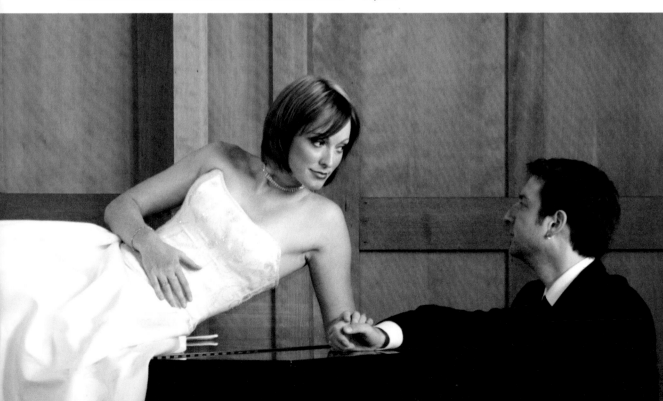

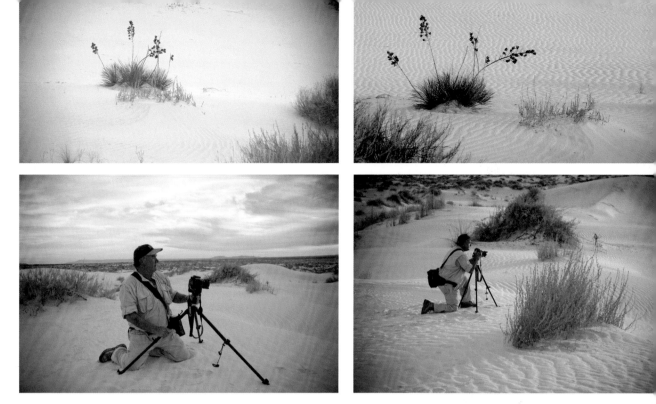

These two sets of images show boring light and great light. Look at the difference in the contrast range, the texture of the sand and plant, the color, and the overall feeling of the images—it can be attributed to patience and time. Both the poorer and great images were shot using sweet light (see page 29), but by waiting a little while, I was able to use the sun as the main light and the sky as a fill light; the "before" shots (top and bottom left) were made with the sky as the main light. Exposures for the top images were: (left) f/7.1 and $^1/_{60}$ at ISO 100 and (right) f/7.1 at $^1/_{50}$ and ISO 100. Exposures for the bottom images were: (left) f/6.3 at $^1/_{125}$ and ISO 100 and (right) f/7.1 at $^1/_{60}$ and ISO 100.

corner facing you. Move around while holding the light finder at eye level. Stop when the two sides appear to be approximately the same shade of gray. At this point, you will have found good light with approximately a 3:1 lighting ratio. Now, there are times when you can use lighting that *does not* make the two shades of paint look identical—you just won't have a 3:1 ratio. In a case like this, determine whether the good qualities the location offers (e.g., an ideal background) compensate for a lack of ideal light.

As I mentioned, a light finder can also be used to determine whether the available light you encounter will be too contrasty to produce a flattering portrait. Simply turn the dark side of the light finder toward the light source. If it appears brighter than the light-

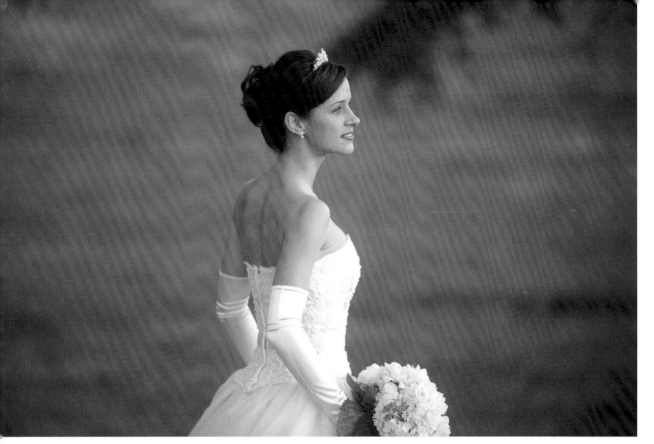

Top—Patience was key in achieving the great light in this image. I waited until the sun dipped below the horizon to capture the shot. Notice the difference in intensity between the light on the bride's face and her back. In this image, the light has a slight blue cast. Exposure: f/2.8 at $^{1}/_{45}$ and ISO 200. Focal length: 200mm. **Bottom left and right**—Be ready. You may only have a few minutes to shoot before the light changes. These images were made before the sun had set. Three minutes elapsed between the creation of the first and second images. Both shots are nice, but the light is very different in each one. Exposures: (left) f/4 at $^{1}/_{60}$ and ISO 200. Focal length 144mm. (right) f/4 and $^{1}/_{40}$ at ISO 200. Focal length: 200mm.

gray side does, the contrast will be higher than 3:1 and you may need to use a reflector, placed opposite the light source, to add fill light to the subject.

Sweet Light. Another way to increase your odds of finding good light is to work with "sweet light." Sweet light is found about thirty minutes before and after sunrise and sunset. When the sun is below the horizon, it yields bounced light, not the hard light that is produced when the sun is in the sky.

The length of time that sweet light will be available to you depends on the weather conditions you are faced with that day. For example, on an overcast day, you may run out of light more quickly than you would on a clear or partly cloudy day.

Using sweet light is the easiest way to create an available light portrait. The lower angle that the light originates from is much more flattering than overhead light—and the light is simply less contrasty during this time. Getting great lighting is a snap: just go outside and turn your subjects' faces toward the setting/rising sun or the brightest part of the sky.

> Sweet light is found about thirty minutes before and after sunrise and sunset.

A movie set on the Rio Grande was a perfect background for this sweet-light portrait. I had the subject turn her face toward the setting sun. Exposure: f/4.5 at $^1/_{320}$ and ISO 100. Focal length: 135mm.

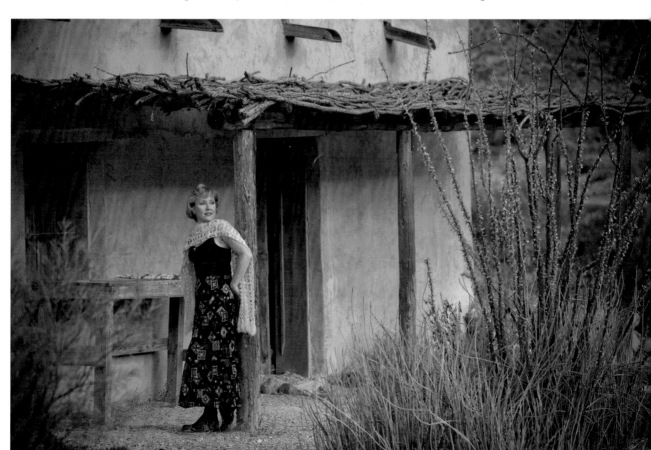

Top left—This portrait was shot when the sun was on the horizon. As you can see, the edge acutance is harder in this portrait than it was in the previous image. The light is warmer in this portrait. Exposure: f/5 at $\frac{1}{80}$ and ISO 100. Focal length: 65mm. **Top right**—I especially enjoy the shadow created by the late-afternoon light. If this image were shot on an overcast day, it would be boring! The subject's red shirt and the warm wood wall added to the overall warm feeling of the light. **Bottom**—One of the greatest things about shooting using sweet light is that the contrast is often so low that the subject can look away from the light source and you can still make a nice image. Exposure: f/4.5 and $\frac{1}{30}$ at ISO 100. Focal length: 200mm.

In the first image (left), we have great subjects, a beautiful background, a nice posing aid, and even good light—but the light is on the side of the subjects' faces. The second image (right) shows that turning the faces into the light made for a much better result.

To photograph this beautiful baby, I placed her near a window in a chair and waited until she turned her head toward the light. Both images are nice, but the light is better in the second photograph.

TURN THE SUBJECT'S FACE INTO THE LIGHT

Many new photographers forget to make sure the mask of their subject's face is lit. They get all of their gear ready, find a great spot, pose the subject, and then forget to turn the face into the stream of light. Most of the time, we are only talking about a slight turn of the face—just a few inches.

It is easy to spot this mistake in the final prints, but it is harder to see the problem when making the image because there is so much light illuminating the subject. Whenever you are shooting a

portrait, get close to the subject and watch them slowly turn their face one way and then the other. Watch for catchlights in both eyes and make sure you there is light on both eyes, the forehead, nose, mouth, chin, and cheeks.

The images on the previous page and below illustrate the difference that lighting the mask of the face makes.

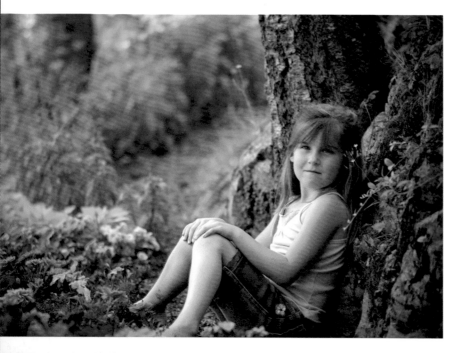

Here is one more set of images that shows how important it is to turn the subject's face to the light. If I had wanted to take the image with the subject looking into the lens, I would have simply had to move my camera into the place where the subject was looking.

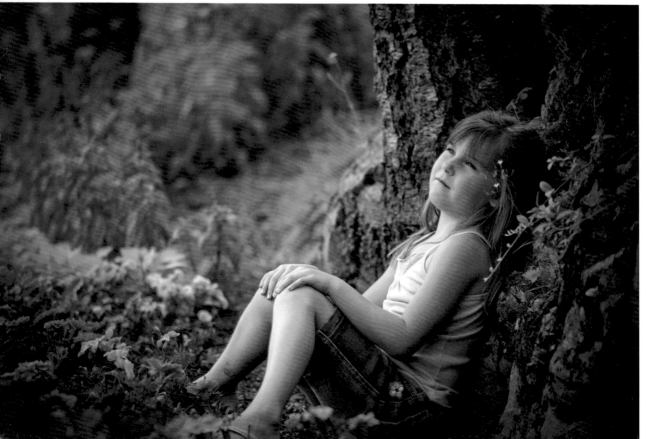

EXPOSURE

EXPOSURE ESSENTIALS

The ISO speed/rating, shutter speed, and aperture (f/stop)—the three components of an exposure—are the basic building blocks of photography. Understanding what each control does, as well as how each of the controls work together, will allow you to produce images with a good range of tones and pleasing contrast.

ISO. Let's start with a look at the ISO. When we shot film, its sensitivity to light was described by its ISO rating. The higher the rating, the greater the sensitivity of the emulsion to light. Digital cameras have a base ISO (determined by the manufacturer); to achieve higher ISO settings, the camera applies some complex mathematical algorithms. Unfortunately, using high ISO settings can result in noise (unwanted artifacts in the image). My rule of thumb is to use the lowest-possible ISO in any given situation. That is why I use a tripod. (My tripod of choice is the Bogen/Manfrotto 458B with the Gitzo 1376M head.)

WHY I USE A TRIPOD

Shooting with your camera mounted on a tripod can make your job a lot easier. Here's why:

· It stops camera shake. A tripod allows me to shoot using a higher shutter speed. This allows me to use a slower ISO, which means there is less noise in my images.

· Using a tripod frees me to move around unencumbered by cameras around my neck. I use a wireless remote to trigger the camera. I also have my camera set to Back Button Focus. This allows me to focus with the Start Focus Button and disengage the focus from the shutter button (a menu function).

· With my camera on a tripod, I can communicate with my subjects eye to eye, rather than from behind my camera. This makes subjects feel more comfortable.

· Using a tripod allows me to look at the scene with two eyes, not just one. When I look at the scene with both eyes, I seem to see things I don't see when I am looking through the camera.

· Many times I need to shoot from a lower camera angle. Bending over or squatting for a long time can be uncomfortable. With the camera on a tripod, I can use the camera angle that suits the scenario and maintain a comfortable position.

· Using a tripod can also make your image editing tasks a little easier. If you take several shots of a family group and need to swap a bad expression on a person's face for a better expression in another image, you'll have an easier time tackling the job knowing the perspective is the same from shot to shot.

Lens selection is important when it comes to establishing the overall look of your image. For portraits, my favorite lens is the Canon 70–200mm f/4. I usually use the 200mm end of the zoom.

Both of these images were shot at f/4. The left image was shot at 70mm. The right image was shot at 200mm. Of course, I had to move the camera back to keep the subject the same size in both images. The background is more out of focus in the image made with the 200mm lens (right), but in the shot made with the 70mm lens (left), the subjects appear distorted.

Shutter Speed. The shutter speed is a numeric representation of the length of time, in seconds or fractions of a second, that the film or image sensor is exposed to light. A longer shutter speed (e.g., $1/60$ second) means light will strike the film/sensor for a longer period of time. A shorter shutter speed (e.g., $1/500$) means that less light will be able to strike the film/sensor.

Aperture. The aperture is an opening in the lens that allows light to strike the film/sensor. The wider the opening (represented by a small f-number, like f/4), the more light is allowed to create the exposure. The more narrow the opening (e.g., f/22), the less light is able to affect the exposure.

Depth of Field. The depth of field in the image—the area of the scene, from front to back, that appears acceptably sharp—depends on three factors: the aperture chosen, the lens focal length (or, on a zoom lens, the focal length setting), and the subject's distance from the camera and the background. Here are some points to consider:

- Opening up your aperture (e.g., changing from an f/8 aperture to f/4) will reduce the depth of field.
- Keeping the subject the same size in the viewfinder and using a longer lens will give you less depth of field.
- If you are focused on your subject, moving the subject farther from the background will cause the background to fall more out of focus.

A lot of people love really fast lenses, but knowing how to use a lens is more important than the amount of glass the lens has. The first image was done with a 50mm f/1.2 lens Canon lens. The exposure was f/1.2 at $\frac{1}{2500}$ second and ISO 100. The second image was shot with a 85mm f/1.2 Canon lens (a really beautiful lens). The exposure was f/1.2 at $\frac{1}{2500}$ second and ISO 100. The final image was shot with a 70-200mm f/2.8 Canon lens. The exposure was f/2.8 at $\frac{1}{320}$ second and ISO 100. There is not a lot of difference between the first two images, but the third image, made with a 200mm focal length, has three stops less depth of field. I like this shot the best. The main difference between the images is the angle of coverage of the lens. If you think about what affects depth of field—the relationship between the camera-to-subject distance and the subject-to-background distance—you would think the third image would have the least depth of field. If you look closely, you can see that the bush is more out of focus in the first and second images—but out of focus is not everything. Angle of view and compression are critical.

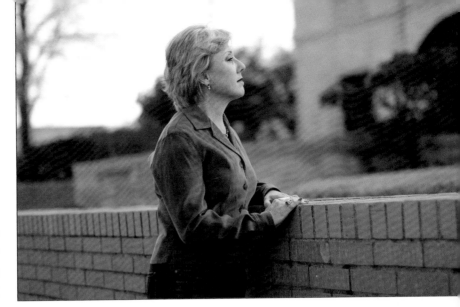

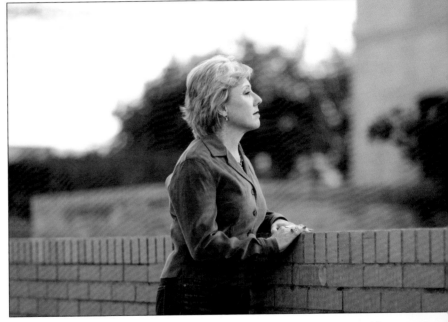

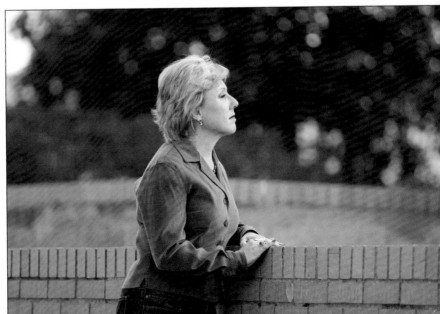

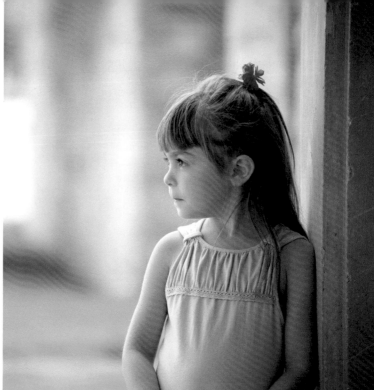

These images were shot with the lens at the 200mm focal length setting. Notice the difference in the apparent depth of field from one image to the next. Keep in mind that the camera-to-subject distance and subject-to-background distance will determine whether your background is in or out of focus.

METERS AND METERING

Incident Light Meters. An incident meter is a handheld accessory meter that is used to read the light falling on the subject. The reading is taken by standing at the subject's position and pointing the meter in the general direction of the light. Because the device reads the light falling on the subject, not being reflected by the subject, the color or tonality of the subject does not influence the reading. I prefer to use an incident light meter to calculate my exposures; I feel that they are more accurate when photographing people.

Reflected Light Meters. Reflected light meters are designed to measure the light that is bounced off of a subject or elements in the scene. The meters built into cameras are reflected light meters, and reflected light meters are also available as handheld units.

Reflected light meters offer various modes that allow the photographer to set the way the camera analyzes the tonal values in

An incident meter is a handheld accessory meter that is used to read the light falling on the subject.

the scene. For example, in the evaluative or matrix metering mode, light reflected by the subject passes through the lens and into the viewfinder, where it is broken into numerous distinct cells that are metered independently. The camera's on-board computer examines every cell and compares the result to an internal database of lighting conditions. The camera selects settings that will ensure the best overall exposure value for the scene. For more information about the metering features your particular camera offers, please see the user's manual.

Many in-camera metering systems offer a spot-metering mode. Using this feature, you can take a reading of a small portion of the image—say, a gray card you have included in the frame—rather than reading the whole scene.

When you are taking a reflected light reading, try to zero in on an area that is 18 percent gray. If you meter something that is lighter or darker than 18 percent gray, the meter will think your image is too light or too dark and will suggest settings that produce an over- or underexposed image. In this portrait, the woman's collar looks like a good choice. Exposure: f/4 and $1/60$ and ISO 200. Focal length: 150mm.

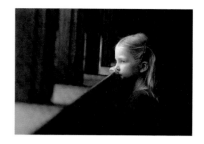

In a scene like this, your camera's evaluative/matrix metering mode will recommend the wrong exposure. In fact, if you're not careful, you'll be fooled too. If you relied on your LCD to judge your exposure, you'd likely deem the image underexposed and would open up your aperture to let more light in. Doing this would result in overexposing the highlights on the girl's face. Exposure: f/5 at $^1/_{125}$ and ISO 200.

Here, I used the evaluative/matrix mode to meter the scene. The meter was thrown off by the large dark and light areas in the scene and recommended two wrong exposures. The scene was identical in each shot, so the exposures should have been the same. Exposures: (left) f/4 at $^1/_{120}$ and ISO 100 and (right) f/4 and $^1/_{60}$ at ISO 100.

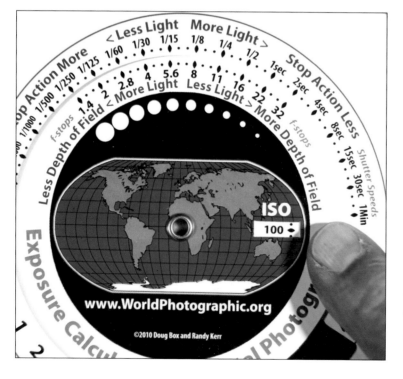

The exposure calculator makes it easy to determine equivalent exposures. If you were shooting at f/4 at $^1/_{30}$ second and ISO 100 but needed more depth of field, you would dial those settings into the calculator, then you could find equivalent exposures that allow you to meet your objectives. You can purchase your own exposure calculator, which is packaged with a one-hour tutorial and an exposure target, at www.World Photographic.org.

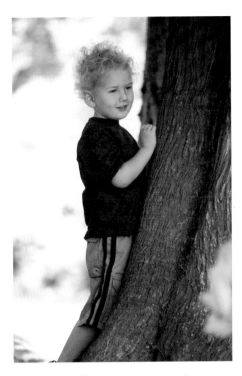

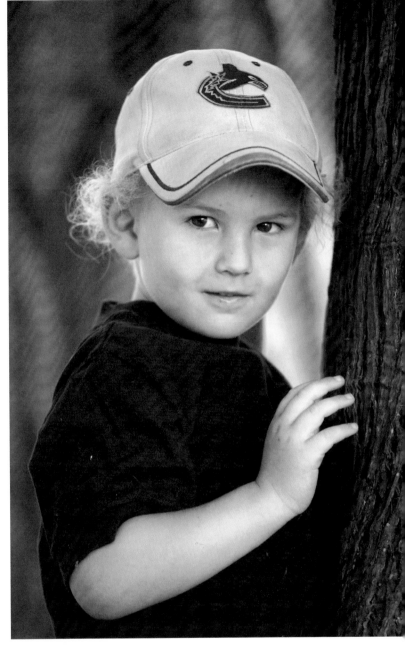

The main difference between these two images is camera position. By simply moving my camera closer and to the left, I was able to get rid of the bright background. This allowed all of the attention to go to the fine young man! Both portraits were shot at f/4 at $\frac{1}{180}$ and ISO 400. Though the light falling on the subject is the same in both images, your recommended exposure would be quite different for each image if you used a reflected light meter in the matrix or evaluative mode. The meter would be fooled by the bright background in the first image and would recommend settings that would result in underexposure. Not good. For this shoot, I opted to use my handheld Sekonic L-358 in the incident mode. I stood at the subject's position with the meter pointed back toward the open sky to measure the light falling on the subject and, as a result, the exposures for both images are consistent—and right on.

BASIC DAYLIGHT EXPOSURE
BY TONY L. CORBELL

Basic daylight exposure, also called the Sunny 16 Rule, is a simple approach that allows photographers to produce a correctly exposed image during daylight hours (when the sun is more than 20 degrees above the horizon), anywhere in the world—without using a meter or taking test shots.

The formula is simple. Any front-lit subject or object should be photographed at $^1/_{ISO}$ at f/16. Let's look at an example: At ISO 125, your exposure would be $^1/_{125}$ second at f/16. With an ISO of 125, you could also use: $^1/_{4000}$ @ f/2.8; $^1/_{2000}$ @ f/4; $^1/_{1000}$ @ f/5.6; $^1/_{500}$ @ f/8; $^1/_{250}$ @ f/11; $^1/_{125}$ @ f/16; $^1/_{60}$ @ f/22; $^1/_{30}$ @ f/3.5; or $^1/_{15}$ @ f/45.

Photo by Tony L. Corbell.

DIGITAL APERTURES

The majority of mechanical film cameras constructed with mechanical lenses offered whole or half-stop apertures. A few models, however, had a "free-moving" aperture that allowed a photographer to select and use an aperture between two full stops.

Today's newer digital cameras and lenses allow photographers to work with fractional f-stops. This can be confusing to some photographers. For your convenience, I've provided a chart that outlines traditional apertures, digital apertures, and apertures as they appear on modern meters.

TRADITIONAL, DIGITAL, AND METER APERTURES

TRADITIONAL	DIGITAL	METER
f/2.8	f/2.8	f/2.8
f/2.8 $^1/_3$	f/3.2	f/2.8.3
f/2.8 $^2/_3$	f/3.5	f/2.8.7
f/4.0	f/4	f/4
f/4.0 $^1/_3$	f/4.5	f/4.3
f/4.0 $^2/_3$	f/5	f/4.7
f/5.6	f/5.6	f/5.6
f/5.6 $^1/_3$	f/6.3	f/5.6.3
f/5.6 $^2/_3$	f/7.1	f/5.6.7
f/8	f/8	f/8
f/8.0 $^1/_3$	f/9	f/8.3
f/8.0 $^2/_3$	f/10	f/8.7
f/11	f/11	f/11
f/11 $^1/_3$	f/13	f/11.3
f/11 $^2/_3$	f/14	f/11.7
f/16	f/16	f/16
f/16 $^1/_3$	f/18	f/16.3
f/16 $^2/_3$	f/20	f/16.7
f/22	f/22	f/22

The easiest way to get the proper white balance is to include a target in the scene, make at least one exposure, use the eyedropper tool in Camera Raw (a RAW conversion program that is bundled with Adobe Photoshop, Photoshop Elements, and Lightroom), then batch process all images taken in that lighting situation. Exposure for both images: f/4 at $^1/_{100}$ and ISO 400.

WHITE BALANCE

Light has color. Some sources produce light that has a warm color cast (think, for example, of the warm light that spills over a subject who is lit by candlelight). Other sources have a cooler cast; for instance, the light at midday on a sunny, cloudless afternoon is a little blue.

All light sources have a color temperature that is described in Kelvin (K) degrees. Candlelight is approximately 1900K. Direct sunlight at midday has a color temperature of 5000 to 5500K. The lower the temperature rating, the warmer the color of the light.

When we were shooting film, we selected a film designed for a given type of light (e.g., tungsten-balanced film or daylight-balanced film). With digital, we use the camera's white balance system, which allows us to neutralize color casts in-camera. Digital cameras offer an automatic white balance option. However, for more accurate, "real life" color, you should rely on one of the white balance presets or create a custom white balance. Consult your camera's users' manual to learn more about these options.

Color Temperatures of Common Light Sources. The following list will help you determine the color (Kelvin) temperature of the light sources you are likely to encounter.:

Candle flame—1900K
Sunrise or sunset—2000 to 3000K
Household tungsten lamp—2500 to 3000K
Quartz light—3200K
Office fluorescent lights—3000 to 4000K
Sun at noon—5000 to 5500K
Hazy sun—5500 to 6000K
Overcast sky—6000 to 7000K
Open shade—7000 to 8000K

It's generally best to avoid using your camera's auto white balance feature. The best color rendition depends on using a custom white balance or relying upon the proper white balance present for the lighting conditions you are working under. Photo by Randy Kerr.

WHITE BALANCE
Camera Settings

 AUTO
The camera sets the white balance for each exposure

 DAYLIGHT
Used for a Bright Sunny Day 5500 Kelvin°

 CLOUDY
The camera adds warm tones about 6500 Kelvin°

 SHADE
Used in the shade with blue sky about 7500 Kelvin°

 TUNGSTEN
Camera adds cool tones 3200 Kelvin°

 FLUORESCENT
Adds Magenta tones From 3500 to 7500 Kelvin°

 FLASH
Used when you are adding Flash 5500 Kelvin

 CUSTOM
Photographer sets the white balance

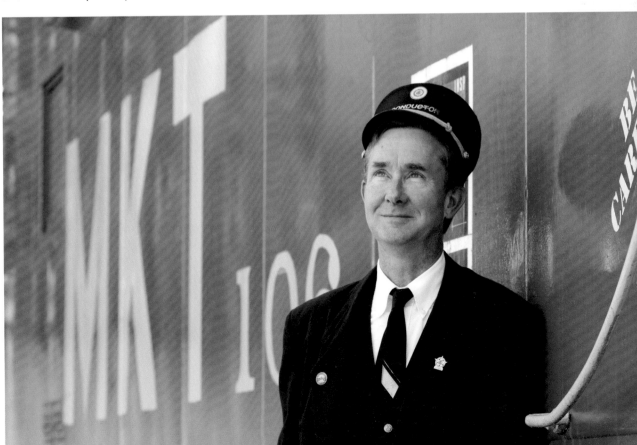

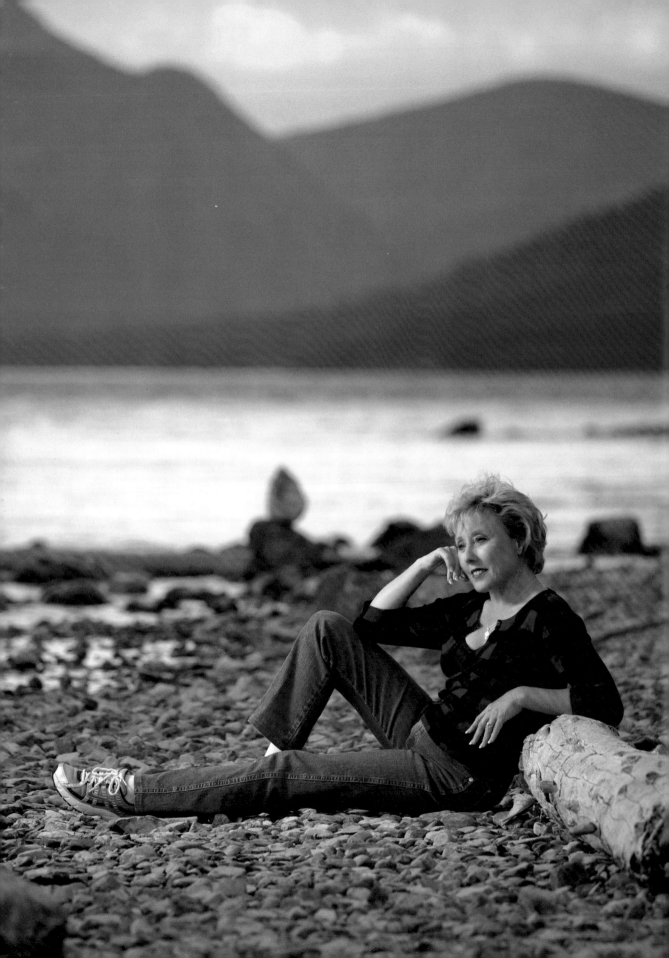

MODIFYING AVAILABLE LIGHT

I f we are lucky, the available light that we encounter in a scene we want to photograph will be perfect as is. As you may suspect, though, that is often not the case. Sometimes the light is too hard and contrasty to produce flattering results. Sometimes it is coming from the wrong direction. Fortunately, there are a host of easy-to-use modifiers that we can use to harness light and achieve the lighting effects we are after. In this chapter, we'll take a look at some of the modifiers that are used with available light.

TRANSLUCENT SCRIMS

A translucent scrim is a device placed in front of a light source to diffuse the light and reduce its intensity. There are a variety of scrims available on the market, but each has a frame that supports a diffusion material. The diffusion materials available allow you to cut light intensity from $\frac{1}{4}$ to a full stop or more. Some photographers prefer to use an open scrim—a modifier with a frame on only three sides so that the scrim's frame does not cast a shadow when it is positioned in front

Facing page—Some available light images, like this one, benefit from modified flash. **Above**—Here, a 72x72-inch FJ Westcott Scrim Jim was used to soften the light. The scrim acted much as a cloud in a sunny sky, diffusing and softening the light. Images by Randy Kerr. Exposure: f/5.6 at $\frac{1}{640}$, ISO 200.

of the light source. I have even constructed my own translucent scrim, making a frame from ³/₄ inch PVC pipe. Today, I prefer scrims from the FJ Westcott line. The frames can be used with the diffusion or reflector panels the company offers. I think everyone should own a 42-inch 6-in-1 Kit Deluxe from FJ Westcott. (Go to www.fjwestcott.com for details.)

Top left and right—Here are two shots made in very hard light—one made with a scrim, the other without. When you use a scrim, the background will be lighter because you are lowering the amount of light on the subject. So, before you shoot, re-meter the light on the subject and reset your camera. Exposure: (left) f/16 amd ¹/₁₂₅ at ISO 100 and (right) f/8 at ¹/₁₂₅ at ISO 100. **Bottom**—Here is Randy Kerr, looking into a translucent scrim and adjusting it for a shot. Note how soft and beautiful the light is on his face. Exposure: f/4.5 at ¹/₅₀₀ and ISO 800.

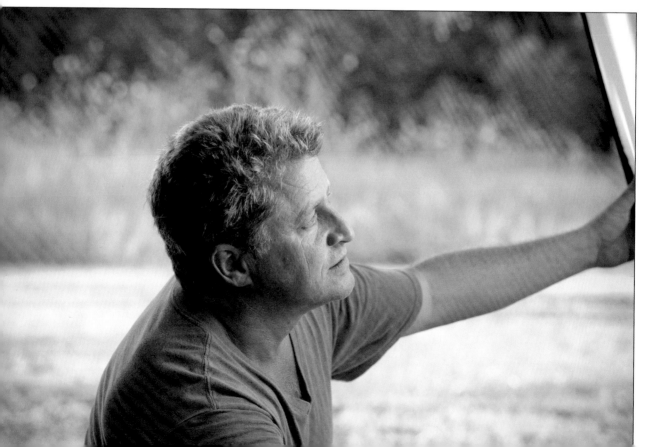

Top—A 72x72-inch Scrim Jim was used to soften the light that came from camera left. A reflector was placed at camera left. The available light served as a kicker or hair light, and the reflector was the main light. Exposure: f/5.6 at $^1/_{500}$ and ISO 320. Photos by Randy Kerr. **Bottom**—Randy used a translucent scrim to soften the sun and make it a backlight. He used a silver reflector to bring light from camera left in as a main light. Exposure: f/2 at $^1/_{5000}$ and ISO 800. Photo by Randy Kerr.

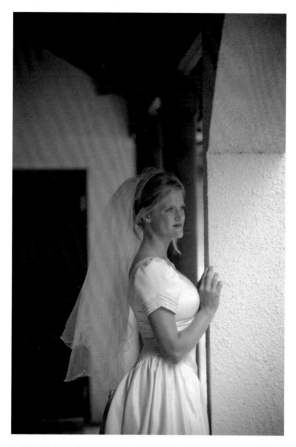

Top left—In this image, the bride's dress is brighter than her face. As you can see, there is a green tint on her face because the light that fell on her was filtering through the trees. The bride was tucked under the overhang of a porch, and the open sky was too high to illuminate her face. The exposure was f/4 at $1/160$ and ISO 200. I generally use the lowest ISO setting my camera offers, but when I teach hands-on seminars, I use the lowest ISO setting that is available to the group as a whole. Usually, one or more students have cameras that cannot be used below ISO 200, so to keep from having to do a lot of converting, we adopt ISO 200. **Bottom left**—A soft silver reflector was used to create this image. As you can see, the skin tones are now the correct color, there is beautiful light on the bride's face, and the mask of the face is illuminated. Note that the catchlights are in the proper position. Exposure: f/4 and $1/160$ at ISO 200. **Above**—This image shows how a reflector should be positioned when it is used as the main light for a standard portrait. Many people position the reflector lower, creating an uplighting effect that is not flattering for every subject. The lower position is best used for producing fill light or when you have the open sky or sun as the main light. Note the surface of this reflector. A soft silver tone is easier on the model's eyes than a very shiny silver modifier. Also, the light that is produced is softer with this type of reflector.

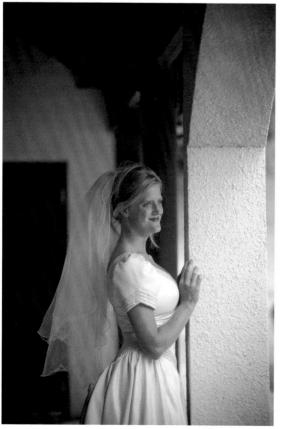

If you use a gold reflector to create fill light, the shadow side of the face will take on a warmer hue. This is hard to correct. I usually use a silver or white reflector for fill. A gold reflector can create a warm main light or a kicker or hair light. Here, I used a 12x12-inch gold fold-up reflector about 30 feet from the subject. I had to move that far away to pick up some direct sunlight to illuminate the subject's hair. Exposure for both images: f/2.8 and $^1/_{250}$ at ISO 160.

REFLECTORS

Photographers use reflectors to bounce light onto the subject or scene. They are available in different sizes and with various surfaces that can be used to intentionally affect the color of the light, making it warmer or cooler.

I use reflectors in many ways—to fill in the shadow side of a subject, as a main light, as a kicker light or rim light, set opposite the main light to add roundness or create tonal separation, to illuminate the background, and more.

Typically I use either a 32-inch round pop-up reflector or a 42-inch Scrim Jim with a reflective panel. However, almost any material with a reflective surface can be used as a reflector. A pop-up or folding windshield shade made of silver Mylar is a perfect emergency reflector. Covering a piece of cardboard with aluminum foil will work when you're in a bind as well. When doing commercial or product photography, I often used small pieces of foil or Plexiglas mirrors to light a small, dark image area. At a wedding, I once used a white tablecloth to reflect light onto the shadow side of a bride's face.

In many scenarios, a flash in a small softbox would work just as well as the bounced light from a reflector—or better—but we are learning to use the light that is available.

The first image (left) was made without a reflector. Look how much better the subject looks when a white reflector was added (center). Notice how closely the reflector was positioned. To use a white reflector, you will need a fairly bright or contrasty light source, as white reflectors are not as efficient as silver reflectors. These images were exposed at f/4 at $^{1}/_{13}$ and ISO 100. My students are always surprised when I use such low shutter speeds for my portraits. Look closely—there is no movement or camera shake. Of course, I work on a tripod and use a wireless remote trigger most of the time. Sure, I could have increased my ISO, but it was not necessary. People don't move as much as you think!

These two images were created with a silver reflector as the main light. The reflector was used at the 45-degree x 45-degree position in relation to the face.

Top right—In this image, the light was coming from all directions, especially from the top. This made Randy's face look wider. In this scenario, Randy's hair was overlit, and the light created dark shadows under his eyes, nose, and chin. **Bottom right**—Once the black flat was introduced, the light came from camera right. The results are much better. **Bottom left**—Here is a Westcott Magic Arm kit with an extra popup flat. I had an assistant hold it so the wind didn't take it away!

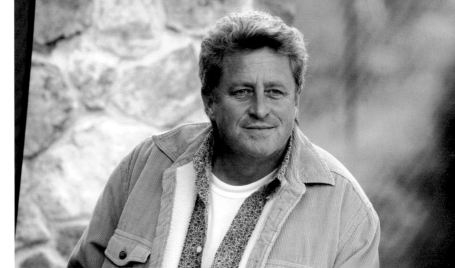

BLACK FLATS

A black flat is a light modifier used to stop light from striking a subject from a certain direction. Also called a black flag or black reflector, these units are used in a subtractive lighting approach.

As you can see in the image on the left, I used two black Westcott popup reflectors, with a Westcott stand and Magic Arm kit. I sometimes use a Westcott Scrim Jim with the black cloth or a Larson black folding umbrella, a 3x6-foot black flat made with PVC and black material.

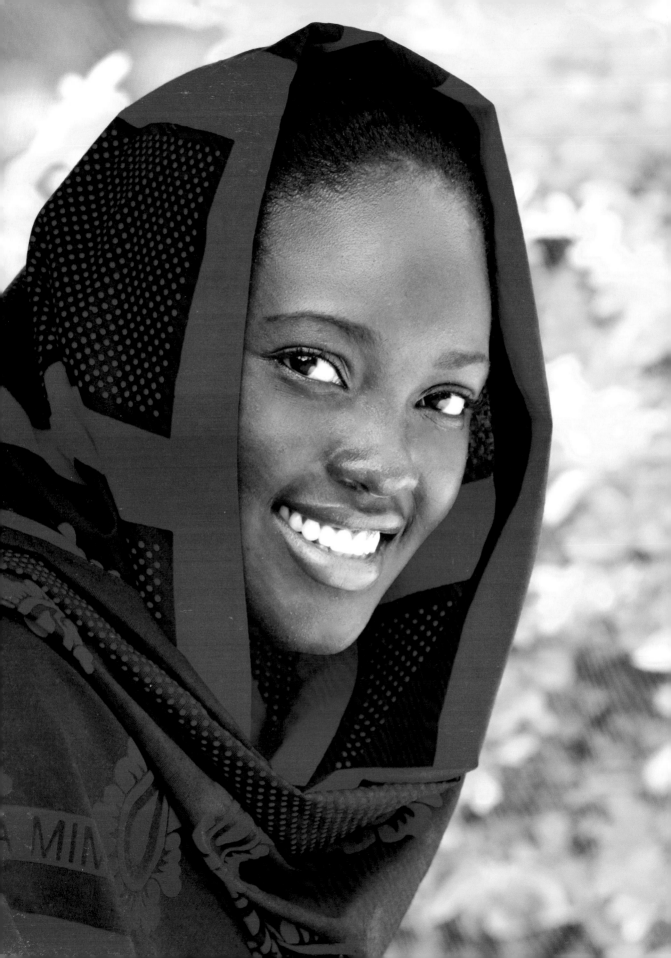

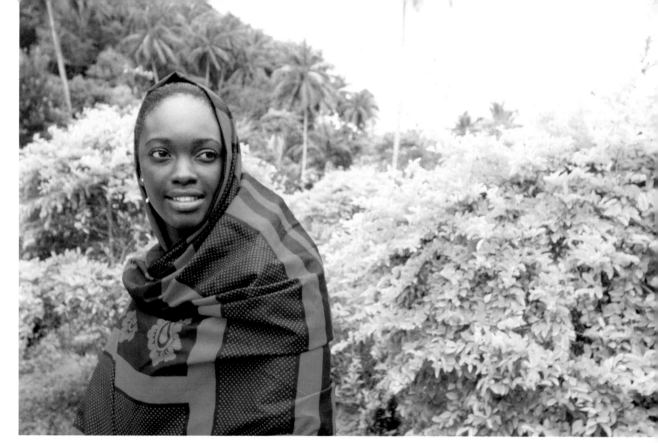

In these images you can see how using two black flats will allow you to control the direction of light in the middle of a field. Notice the beautiful light on the model on the facing page. Photos by Randy Kerr.

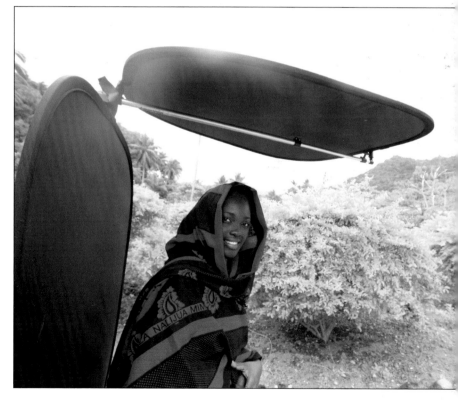

Look at the difference that using an overhead block makes on our beautiful model's face. Also note the change in the lighting on the top of her head and shoulders. When using an overhead block, you can finness the effect of the light by moving the subject closer to or farther from the edge, just as you would when you are shooting on a porch or using a black flat. What a great investment for $49.

OVERHEAD BLOCK

I own a photography forum called ProPhotogs .com. One of the members asked me how to solve a problem she was having with overhead light whenever she was photographing in an open area. The light seemed to come from everywhere, and her subjects were all rendered with overlit, blown-out highlights in their hair and

dark, unflattering shadows on their faces. I offered a number of solutions: shoot on a porch, add off-camera flash, use a black flat, move the subject under some tree branches. "Too much trouble," she replied.

My feeling is, as a pro, making your subject look great should never be too much trouble—but her statment got me thinking. I needed a solution that was simple, inexpensive, and fast. That weekend, I stumbled across an advertisement for a popup canopy in my Sunday newspaper. I bought one for $49 at Academy. It sets up quickly (after a trial run), it is stable even in a light wind, and it works great.

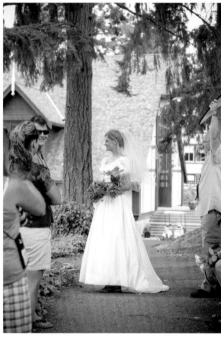
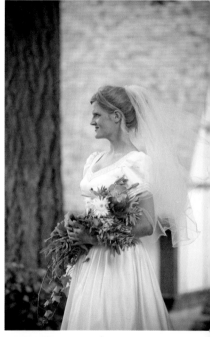

Here, a more traditional over-head block was used. You can easily see the difference it made in these images.

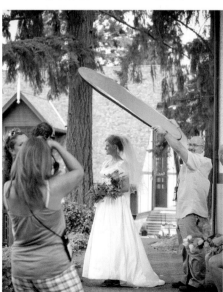
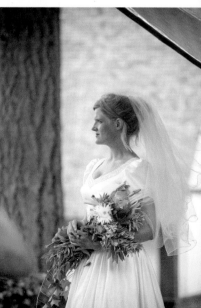

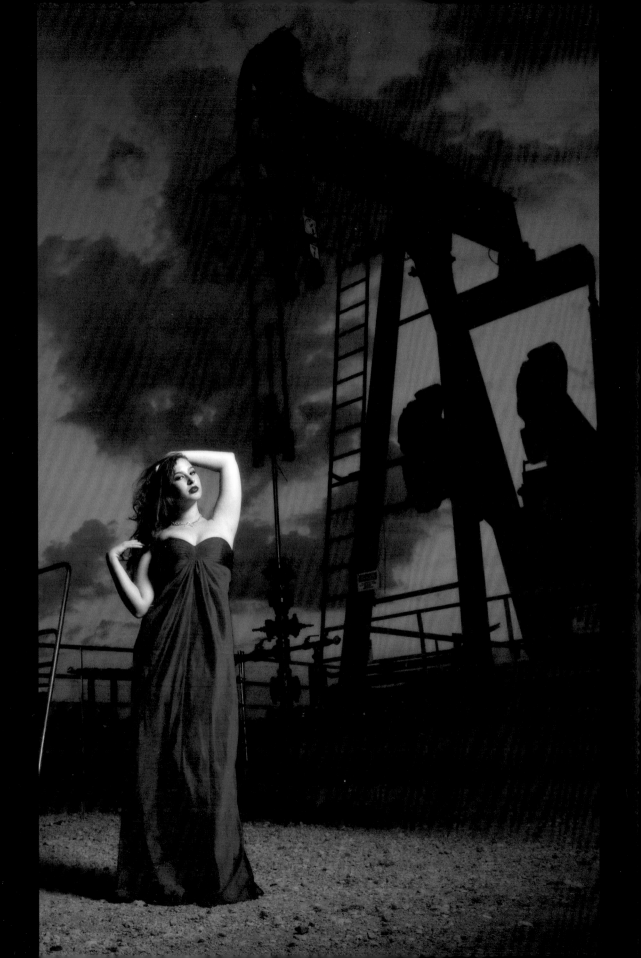

Facing page—Here is another situation in which off-camera flash worked well—and that's because there was no available light! Using off-camera flash allows me to light the subject and control the brightness of the background. **Above and right**—Here's a great example of a situation in which adding flash improves the image. In the first image, there are dark circles under the subject's eyes, grayish skin tones, and blown-out areas on the top of the shoulders and the dress at the ground. There was no open sky to yield good color. Look at the difference adding off-camera flash made. My requirements for off-camera flash use is that the top light shadows are corrected and the mask of the face does not have that "flashy" look that on-camera flash creates.

ADDING FLASH

Yes, this book is about available light. The truth is, though, there are some situations in which you may want to supplement available light with flash.

The sample images and captions illustrate and describe how adding flash helped improve the overall exposure in several photographic scenarios. For additional information on using flash, please see *Doug Box's Flash Photography*, published by Amherst Media.

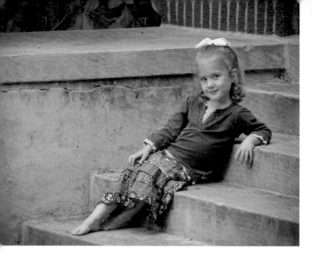
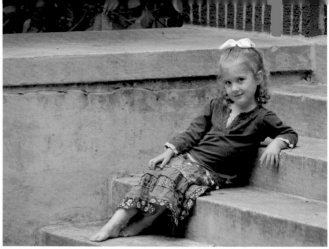

Here is a situation where off-camera flash and a black flat would work equally well. As the artist, it is up to you to decide which tool of the tools in your toolbox you want to use.

Off-camera flash is also helpful when photographing large groups. After all, it would be tough to find and use a black flat that is large enough to block the overhead light from striking a group of this size.

AVAILABLE LIGHT AND COMPOSITION

When working with natural light, we must sometimes bend or break the rules of good composition in order to get the best possible light on our subjects. When possible, however, we should strive to follow the traditional compositional guidelines.

THE GOLDEN MEAN AND THE GOLDEN SPIRAL

The Ancient Greeks believed there are three components to beauty: symmetry, proportion, and harmony. We can attribute two composi-tional strategies to the Greeks: the golden mean and the golden spiral.

The illustration and images below show the principle of the golden mean. When you look at the silhouette of the woman, note that the composition was improved by reframing the image to place the subject at one of the power points.

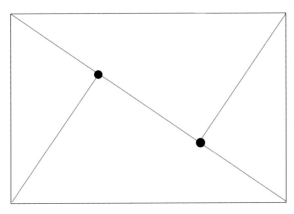

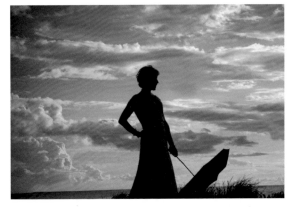

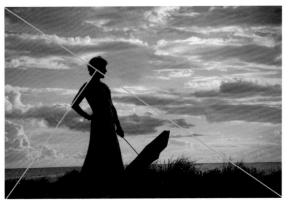

Above—The golden mean provides two power points—places where the most critical aspect(s) of the image should lie for the optimal compositional arrangement. **Top and bottom right**—These images show how using the golden mean can help create a less stagnant, more engaging image.

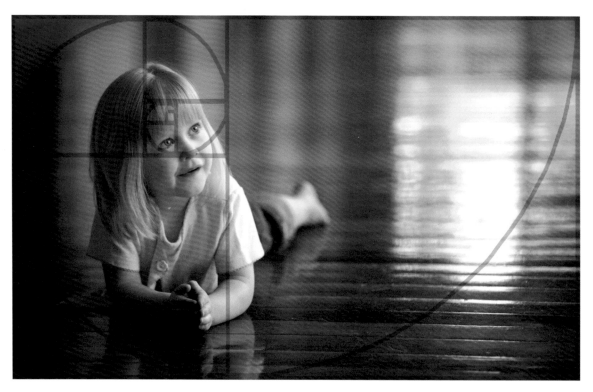

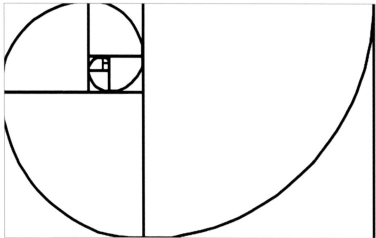

Left—The golden spiral can help you create a naturally flowing image. **Above**—This is one of my favorite child portraits. When she lay on the floor, I had about 5 seconds to make the exposure. Studying and training comes in handy in helping you create a solid composition quickly. Sure, I could have cropped the image in postproduction to get a pleasing image, but doing so could mean that the subject is too tightly cropped or that the resulting file is too small, with insufficient data to make a pleasing, sharp, grain-free image.

THE RULE OF THIRDS

The rule of thirds is probably the most often-used compositional guideline. Imagine dividing your image into thirds horizontally and vertically. (In other words, pretend you are drawing a tic-tac-toe grid over your scene.) When composing the shot, simply place the main subject at one of the four points where the horizontal and vertical lines intersect.

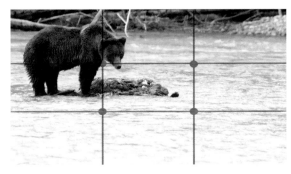

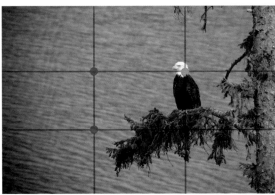

Above—The superimposed grids on these image show how the rule of thirds was employed to place the subject in the most aesthetically pleasing area of the frame. **Top and bottom right**—Here are two different presentations of the same scene. The first image was not very effective, so I changed the camera angle and changed lenses to create a more interesting representation of the scene. When on vacation, it can be easy to get lazy and snap a shot without really thinking it over, but as you can see, taking a little extra time is worth the effort.

Facing page—Sometimes, you need to throw the rules out the window and compose or crop the image however it seems pleasing to you, as the artist.

All aspects of the image must work together to support the message and feel of the photograph.

OTHER IMAGE-ENHANCING STRATEGIES

The Photographic Exhibitions Committee, a part of the Professional Photographers of America, uses twelve criteria to define a merit image. The committee trains judges to be mindful of these elements when reviewing images to determine which will make the cut and be placed in the International Print Exhibit at Imaging USA, the association's annual convention. These twelve criteria are:

- *Impact.* This relates to the impression an image creates when it is viewed for the first time. An image should be compelling. It should evoke laughter, sadness, anger, pride, wonder, or another intense emotion. Impact can be achieved through the use of any of the other elements.
- *Creativity.* This refers to the original, fresh, and external expression of the imagination of the artist by using the medium to convey an idea, message, or thought.
- *Technical excellence.* This criteria deals with the print quality of the image presented for viewing. Retouching, manipulation, sharpness, exposure, printing, mounting, and correct color are all taken into consideration when the print is judged.
- *Composition.* Composition is important to the design of the image. All aspects of the image must work together to support the message and feel of the photograph. Proper composition holds the viewer's gaze and leads the eye through the image as the artist intends. Effective composition can be alluring or disturbing, depending on the intent of the image maker.
- *Lighting.* The lighting in an image determines how dimension, shape, and roundness are created. Whether natural or man-made light is used, it should enhance the overall quality of the image.
- *Style.* Style is defined in a number of ways as it applies to a creative image. The term may relate to a specific genre or specific characteristics of the creation (for instance, the way the specific artist applies light to the image). When the style and subject matter go hand in hand, the image style is an asset. When the style and subject are not harmonious, it is possible, however,

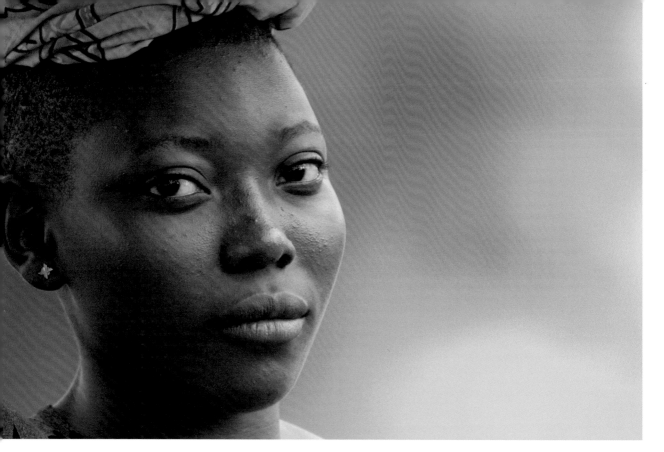

for the style of the photograph to detract from the overall message.

- *Print presentation.* Print presentation affects an image by giving it a finished look. The mats and borders used should support and enhance the image, not detract from it.

- *Center of interest.* The center of interest is the point or points on the image where the artist wants the viewer to focus on as they look at the photo. It is common for an artist to incorporate primary and secondary points of interest; sometimes, there is no center of interest—and the composition or scene as a whole serves as the center of interest.

- *Subject matter.* The subject matter of the image should always be appropriate to the story being told in the photograph.

- *Color balance.* Color balance lends harmony to an image. When the tones in an image work together and support the overall feel of the image, the emotional appeal of the artwork is enhanced. Non-harmonious colors can be chosen for effect; they can create a discordant mood that engages the viewer.

This arresting portrait was composed to ensure that the subject's eyes occupy the upper-left third of the image. It's a powerful presenation. Photo by Randy Kerr.

- *Technique*. Technique is the approach used to create the image. Printing, lighting, posing, capture, presentation media, and more are part of the technique of the image.
- *Storytelling*. Storytelling refers to the image's ability to evoke imagination. One beautiful thing about art is that each viewer might collect his own message or story in an image.

For more information about Professional Photographers of America, go to their website at www.PPA.com.

IN CONCLUSION

So far, we've touched on a wide range of topics that apply to working with available light. In Part 2: Practical Applications, we'll take a look at a variety of portraits—as well as travel photos, sports photography, and nature shots—made by myself and Randy Kerr. You'll learn how to solve common lighting problems or challenges to create the best-possible results—images with dimension, mood, and a storytelling quality that will help you achieve your artistic goal and stand out amongst the competition.

The contrast of the bright white dress against the darker surroundings ensure the viewer's gaze is locked on the subject. Photo by Randy Kerr.

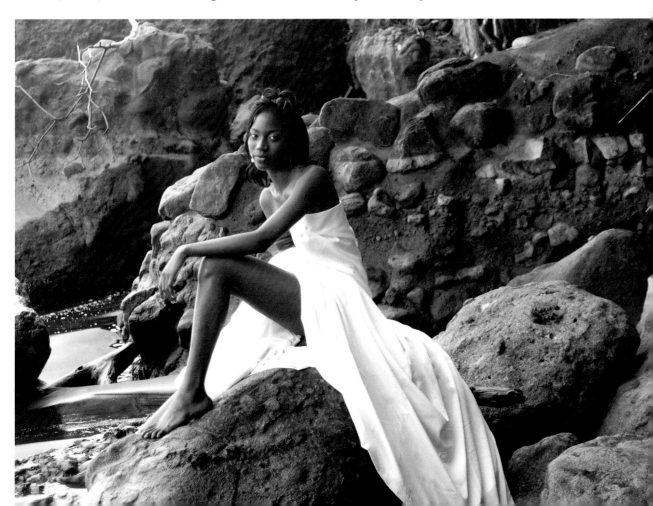

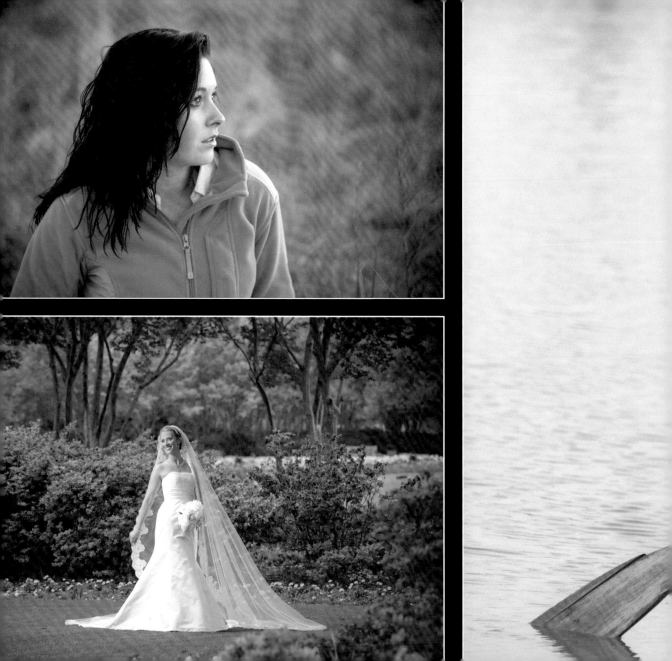

WINDOW LIGHT

When you are shooting outdoors, there is light coming from every direction. This can make it hard to "read" the effects of, say, overhead light, side light, or any added fill. When you work with window light, it is much easier to recognize good lighting. So, working with window light makes for a good starting point for learning to produce great available-light images.

When I am planning to create a window light image, the first thing I consider is the quality of the light.

My favorite window light comes from an open sky—a beautiful blue or gray sky that is not obscured and affected by trees, buildings, or other structures, which can change the color and quality of the light. When open sky light comes through an opening like a window, its softness is maintained. Soft light tends to be flattering for portrait subjects.

In some cases, the light coming through a window will be hard, direct sunlight. For example, you might encounter hard light if you are shooting at noon on a day when the sun is shining brightly and there is not a cloud in the sky—and there are no trees or curtains to diffuse the light—or buildings to block or bounce it. Hard window light can be beautiful too.

Facing page—Adding a reflector can lighten the shadow side of the subject and reduce the contrast range. Exposure: f/4.5 and $1/20$ at ISO 800.

So, in a typical portrait session, I may decide to take advantage of open sky window light. I would check to make sure that, with the subject positioned at the window, he or she could see open sky, not trees or buildings, as these things can add a green cast to the lighting and change the quality of the light overall. Once the subject is able to see open sky, I will determine where to place my camera.

CONTRAST

As you start using window light, one of the first things you will notice is the contrast the light creates on your subject. Simply put, when the diffused highlight area is very bright, the shadow areas are black, and there is a swift transition from highlight to shadow, the light is hard and there is a high contrast range. Again, softer light is ideal for most portraits. So, when the window light is soft, we will see a less dramatic contrast range presented on the subject. For example, the light may fall gently on the side of the subject that is closest to the window, then slowly transition to soft shadow.

There are several factors that control contrast:

- *The size of the window.* The light from a large window will have a lower contrast range than the light that comes from a small window.
- *The reflectivity of the walls in the room.* If the walls of the room you are working in are

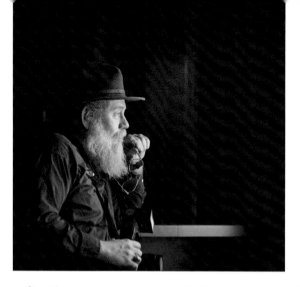 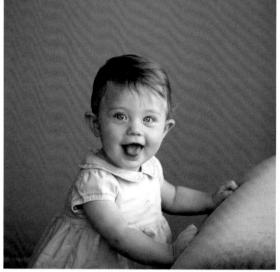

Left—This image was made with light from a small window about 6 feet directly in front of the man. Notice the abrupt falloff from light to shadow and the darkness of the shadow. **Right**—In this scene, the subject was positioned about 12 feet from several medium to large windows. The room was about 15 feet wide, and walls were painted a light to medium color. Exposure: f/4.5 and $^1/_{80}$ at ISO 400.

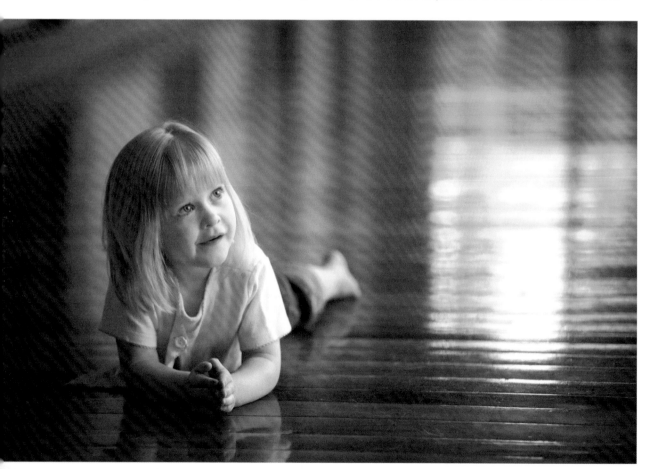

The subject was illuminated by a large bank of windows about 10 feet away. Note the way the light falls off gradually. As you can see, the shadows produced by the light that came through the larger windows are softer than the shadows produced by the light that came through the single small window used to make the image of the toddler at the top of the page.

white or light in color, the contrast range in your image will be lower. When you are shooting in a room with dark walls, the contrast range will be higher. The size of the room will also affect the contrast. If a woman is posed against a wall and there is a window across the room, 10 feet away from her, the light will be harder than it would be if we posed her in a room in which the window was 30 feet away. This is due to falloff.

- *Other windows or lights in the room.* If you have lamps, other lights, or windows in the room, that light will strike the shadow side of the subject and lower the contrast ratio. (The other light may have a different color balance, and this could also impact the overall look of the image.)

- *The subject-to-window distance.* As you move the subject away from the window, the light falls off and is less intense on the highlight side. However, the shadow side remains relatively the same because it is lit by the light bouncing around the room. The farther the subject is moved from the window, the lower the contrast range. *(Note:* With less light striking the highlight side of the subject, you will need to make the appropriate exposure adjustments.)

In the room where this image was shot, there were several tall, thin windows about 10 feet from the subject. The room was about 60 feet wide, and the walls were a light to medium color. Exposure: f/4 and $^1/_{25}$ at ISO 100.

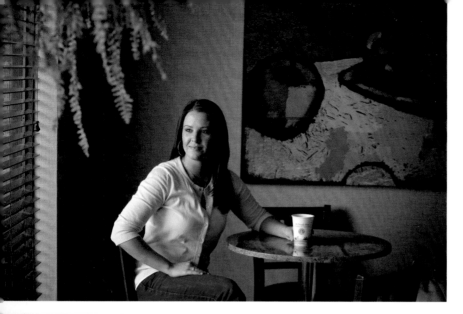

These two images show vastly different contrast ranges. In the first image (left), the subject's face was about 3 feet from the window. The first image was shot at $^1/_{40}$ second at f/4 and ISO 200. In the second image, her face was about 10 feet from the window. The contrast was reduced because the light fell off over the greater distance, rendering the highlight side of the subject less bright (the shadow side tones remained the same). This image was shot at $^1/_{15}$ at f/4 and ISO 200. The second image needed $1^1/_3$ stops more exposure. Note the difference in the overall brightness from one image to the next.

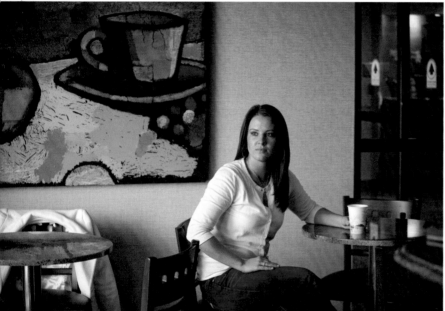

If you are working with window light and you're not getting the contrast range you are after, try these strategies:

- Move the subject farther from the window.
- Use a reflector to bounce some of the light coming from the window onto the shadow side of the subject.
- Use additional light in the room. This can be as simple as opening curtains, turning on room lights, or supplementing the available light with flash.

Here we have two images made in the same room. In each case, the light came from two 4x6-foot windows. In the full-length photo, the subject was placed 4 feet from a light-gray wall and 16 feet from the window on the opposite wall. In the close-up image, the subject was positioned in the center of the room; she was 10 feet from the window and 10 feet from the wall. What a difference moving the subject just 6 feet closer to the light source made. Exposures: (left) f/4 and $^1/_{30}$ at ISO 2000, with a focal length of 47mm and (right) f/4.5 and $^1/_{60}$ at ISO 2000 and 85mm.

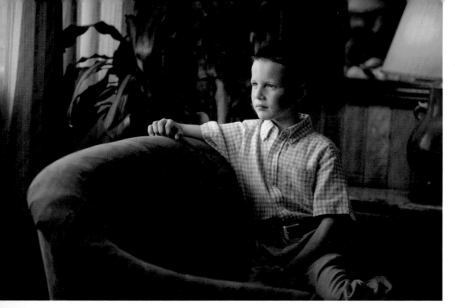

All of these images were shot at f/4 at $\frac{1}{40}$ and ISO 100. They are correctly exposed. In the top left image, no flash was used. In the bottom-left image, I added flash, set to -1, to fill in the shadow side of the face and the clothing. If you wanted less fill (more contrast), you would turn the on-camera flash down to -2 or -3. The top-right image was shot without flash. For the bottom-right image, I added fill. The flash was set to -2. I like this much flash; I think the lighting still looks natural.

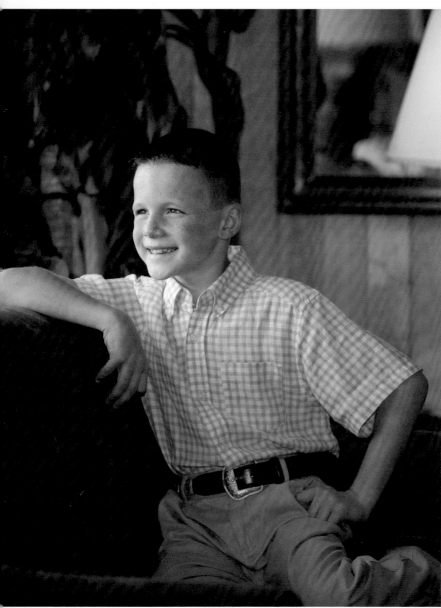

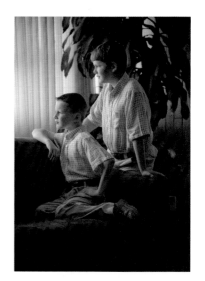

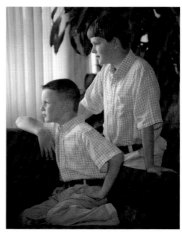

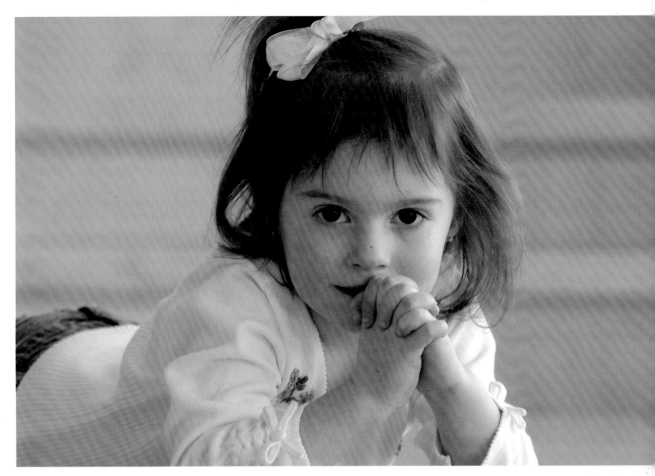

When you look at a photograph, try to figure out how it is shot. Ask yourself how the image was lit and what exposure the photographer used. Let's analyze this image. The soft edge acutance tells you a large light source was used. Look at the catchlights; there is no reflector or flash to fill in the shadow side, so there must be other light sources in the room, like other windows or other lights. The background is somewhat out of focus, so you know that either a wide-open lens or a long lens was used to capture the image. Look closely at the depth of field; the subject's hands, eyes, and hair are sharp and the jeans are relativity sharp, so you can surmise that the aperture was not as wide as f/2 or even f/2.8. This image was shot at $^1/_{30}$ at f/6.7 and ISO 100. There were large windows at camera right and other windows in the room.

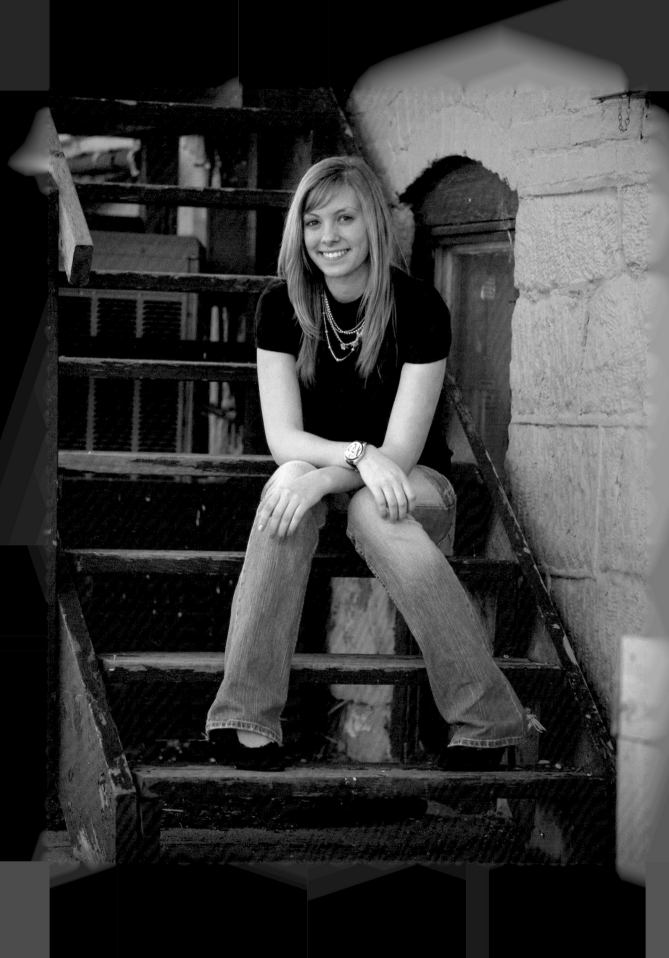

PORCH LIGHT

Now that you have learned how to use window light and, more importantly, to see the light, you are ready for the next step in this journey of mastering available light. We will turn our attention to working in an area with an overhang—like a roof or an awning—to block overhead light. In these examples, I will show how shooting under an awning or on a porch—for simplicity's sake, we'll call it porch light—where light is blocked from overhead, can yield soft, directional lighting that will flatter your subjects.

Light that streams across a porch is like the light coming through a window. What makes

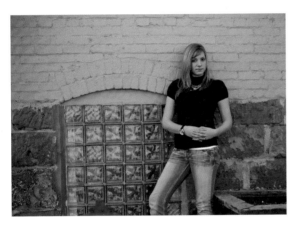

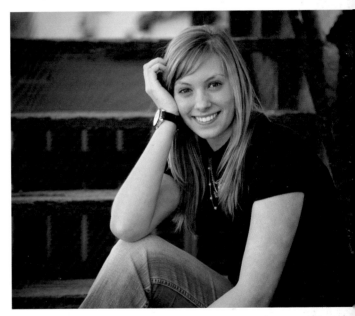

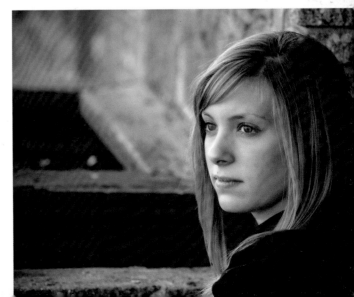

Facing page—An architectural feature like an awning or a roof can create directional light that is ideal for any portrait subject. **Top left**—Here, the open sky was directly behind me and above the model. The lighting on her face was flat. The dark circles under her eyes were caused by top light. A little more light came from camera right, and her hair blocked some light on her right cheek. Exposure: f/4 and $^1/_{320}$ at ISO 100. Focal length: 70mm. **Top right**—I moved the model under a small overhang. See how much less light was coming from above? Exposure: f/4 and $^1/_{320}$ at ISO 100 and 150mm. **Bottom right**—I moved the camera to the right to ensure even more direction to the light. Exposure: f/4 and $^1/_{320}$ at ISO 100. Focal length: 150mm.

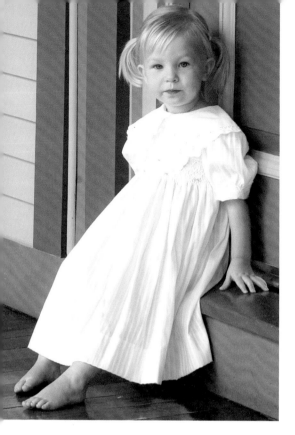
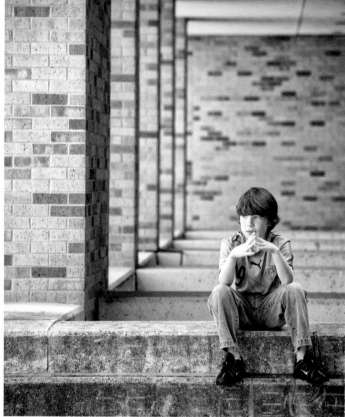

Left—You can easily see how effective porch light is. Remember to turn the subject's face into the light. There may be good light in a situation, but you still have to use it correctly. Once you turn the subject's face into the light to illuminate the mask of the face, you should move the camera to photograph different views of the face. **Right**—I use NIK Silver Efex Pro 3.0 for my black & white conversions. There is no better software on the market for converting images. Exposures: (left) f/4.8 and $\frac{1}{60}$ at ISO 160. Focal length: 200mm. (right) f/5.6 and $\frac{1}{125}$ at ISO 200. Focal length 200mm.

porch light so great is that, when you and your subject are positioned so that you are shooting down the length of the porch, the majority of the light comes from one direction—the side opposite the house. Because the house itself blocks the light from striking the subject on one side, the light will not be flat.

On a porch, the roof blocks overhead light. (You will learn to appreciate overhead blocks when you work with natural light.) Overhead light (like the sun at midday) can create harsh, unflattering shadows on your subject.

When working with porch light, you can control the intensity of the light by changing the subject's position. The closer the subject is to the edge of the porch, the more intense the light will be and the higher the contrast range. You typically won't need to add a lot of reflected light when you are shooting on a porch. Concentrate on seeing the light. From a photographic point of view, the best way to see the light is to get really close to your subject. If you can't see the light, you can't control it.

OPEN SHADE AND OPEN SKY

The majority of my available light portraits are made using open shade. A subject is in open shade when it is located in a shaded area on a sunny day. For the best portraits, look for something to block the light coming from the top and one side. As you learned earlier, walls and roofs block light from overhead and from the side. When we are photographing away from buildings, trees limbs and branches can block some of the light. (If you are under the shade of a tree, make sure you do not have spots or blotchy light striking the face or front of the subject.) Rock overhangs and outcroppings can also block the light for you.

When working in open shade, I am looking for a clear area of open sky to illuminate the subject—not direct sunlight, but bounced light. My first choice is blue sky, but I will take gray. Since I live in the Northern Hemisphere, the sun starts its daily journey in the east, travels through the southern sky, and sets in the west. That means, in the morning, the north and the west have open sky; in the middle of the day, the north has open sky; and in the afternoon, the open sky is in the east and north.

The greatest things about open shade are: (1) the light has a consistent color; (2) it offers a soft and even light that has a smooth edge acutance;

In this scenario, the light was good but not great; having an overhead block would have made it better. Take a look at the highlights and shadows in the image to try to determine how the image was lit. Notice that the back of the subject's hand is bright. This is because it faced the open sky. Now, look at his arm. The top of his arm appears brighter than the bottom. This is due to top light. You will also notice that the top of his head is bright and there are tell-tale dark shadows caused by his eyebrows. The light seems to work in this instance because he is looking away from the camera and there is light coming from the side.

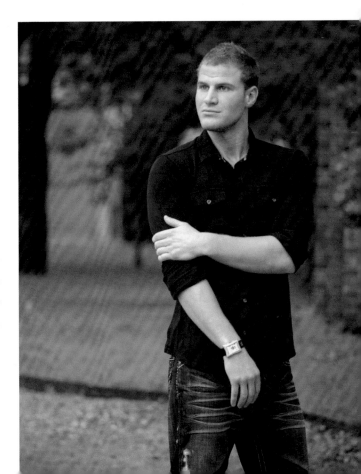

(3) the light that comes from the open sky is not as bright as the sun, so your subjects are less likely to squint.

WHITE BALANCE

When it comes to white balance, open sky light is similar to window light and porch light. Try the Shade white balance preset on your camera if the sky is blue, or use the Cloudy preset if the sky is gray. You can also do a custom white balance if shooting in the JPEG mode. Since I shoot almost everything in RAW, I include a white card or target in one image every time I shoot in a different lighting situation. I use the back of the Exposure Calculator

Below—Notice how the open sky coming from camera left illuminated the face of the man in the canoe. His hat provided the overhead block for this face. Exposure: f/5 and $^1/_{80}$ at ISO 140. **Facing page**—Look closely at the light on this little guy's arm and hand. Where did the light come from? That's right, it came from the left and from above. I chose to take a photojournalistic approach to capturing this image. If the subject had looked at me, there would have been dark circles under his eyes. Exposure: f/3.3 and $^1/_{30}$ at ISO 160. Focal length: 200mm.

NORTHERN LIGHT

Early photographers realized that the best, most flattering light came from the north almost all the time. Most early available light studios had a large angled glass wall that pointed north so they could take advantage of this beautiful, flattering light.

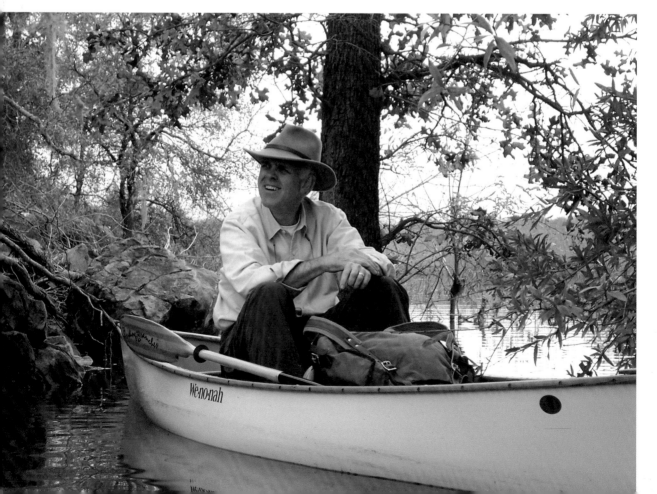

as my white balance card. I can then open Lightroom or Bridge, use the eyedropper tool to sample the white card or target, and remove color casts. Note that the back of the Exposure Calculator has a slight coolness to it. When you sample it, you end up with a slightly warm color balance, which I love.

Photographing in open shade can be simple and effective. Simply position your subject in a location with a large area of open sky on one side and something to block the light from the other side, and you can make a great image! Exposure: (top) f/4.5 and $^1/_{50}$ at ISO 100. Focal length: 144mm. (bottom) f/5 and $^1/_{80}$ at ISO 200. Focal length: 187mm.

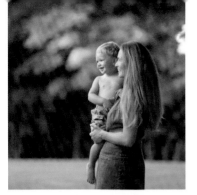

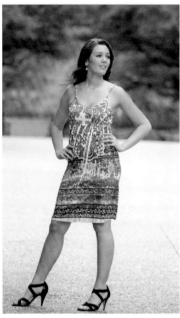

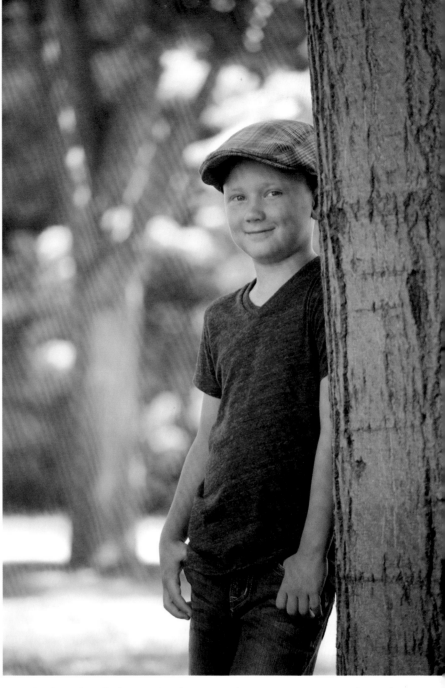

Top left—Posing this mother and son at the edge of the wooded area allowed the blue sky to their right to illuminate the boy's face in the $^2/_3$ view and the woman's in a profile position. Exposure: f/3.3 and $^1/_{30}$ at ISO 160. Focal length: 200mm. **Bottom left**—Sometimes you find perfect light. In this location, there were tree branches to block top light and buildings and trees to camera right to block light coming from that direction. If you stood where the subject was standing and looked toward the camera, you would see a patch of open sky parallel to the camera view on your left. If you looked up, you would see green leaves. To your right (camera left), you would see more leaves. The key to the success of this image is the open sky. Exposure: f/4 and $^1/_{200}$ at ISO 200. Focal length: 200mm. **Right**—In this situation, I found a location with overhead branches to block the light, but the area behind the camera was fairly open. I backed the young fellow up, allowing the tree to block the light from one side. If you look closely at his left cheek and neck, you can see there is beautiful kicker light coming from the open sky behind him. Exposure: f/4 and $^1/_{100}$ at ISO 200. Focal length: 200mm.

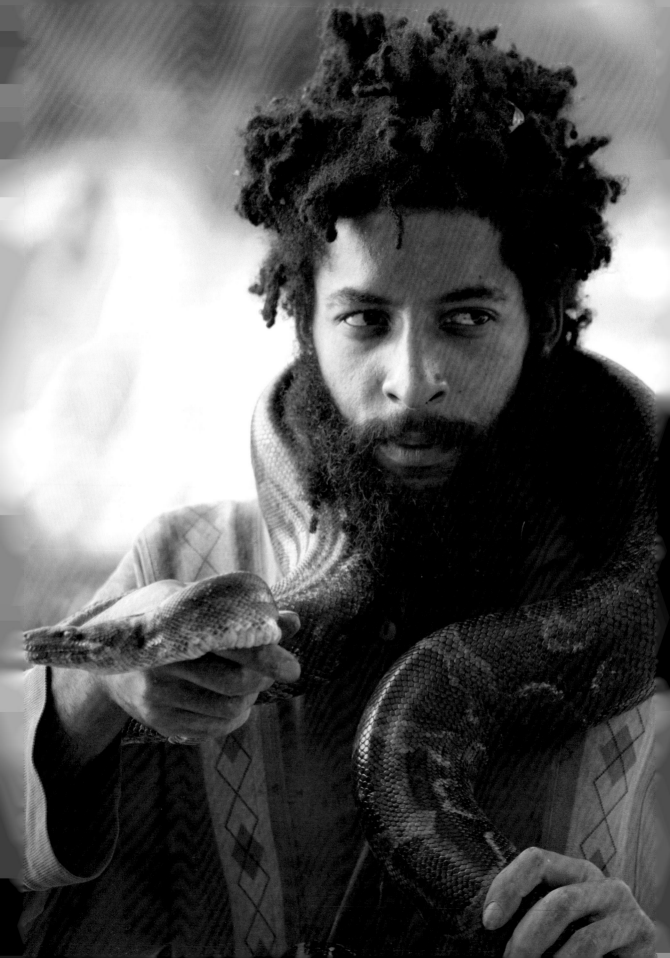

DIRECT SUNLIGHT

I probably get more questions about how to shoot in direct sun than I do about any other topic. I'm asked, "How can I shoot at noon, in direct sun, and get rich colors, wonderful directional light, and not capture people squinting and with the tones on the tops of their heads blown out?" My response is, "Get lunch and wait until later in the afternoon!"

That is not what they want to hear. Okay, here are some suggestions that are not as smart-alecky.

- Find a model who can keep their eyes open in bright light, or have your model close their eyes or put on sunglasses. (Okay, I admit, that's still a bit smart-alecky.)
- Create a storytelling image that allows you to work around the ill effects of bright light.
- Backlight the subject and expose for the diffused highlight.
- Hone your nature photography skills. Direct sun can make for dramatic nature photos.

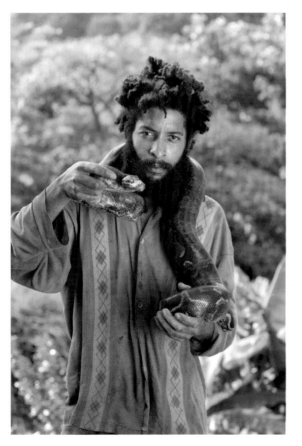

The best way to shoot in direct sunlight may be to backlight the subject (use a translucent scrim to decrease the intensity of the light so it will not appear blown out), then add a reflector to increase the exposure on the face. The first image was made with direct, unmodified light. The second image shows the setup. For the final image, I had my assistant hold the reflector (a Sunlight reflector, part of FJ Westcott's 6-in-1 Kit Deluxe) high to ensure the catchlights would appear at approximately the 2 o'clock position.

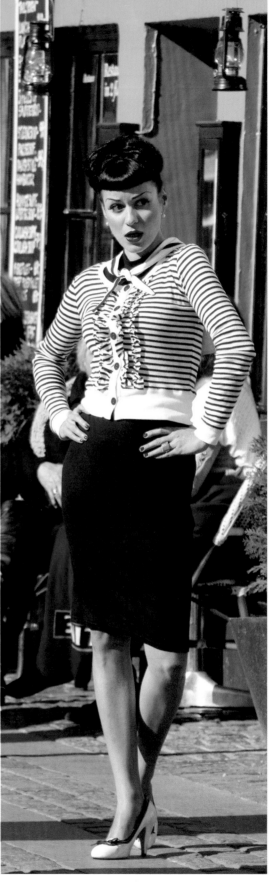

Top left—Every once in a while, look behind you while shooting. This photographer and I were both shooting the same subject, I looked back and saw this great shot of my friend. Stay aware of everything around you, not just the apparent subject.

Bottom left—Get creative when you're forced to shoot in full sun. Here, the model's upturned face was washed in full light—but his closed eyes helped to create a feeling of exuberance or joy.

Right—This image was shot in direct sun, and the model managed to keep her eyes open. Note the hard edges where the light transitions to shadow—that is proof positive that the shot was made in full sun.

Top left—Backlight the subject and expose for the diffused highlight. Sometimes this will blow out the backlighting. You may need to use a reflector to raise the amount of light in the diffused highlight area to reduce the contrast range. **Bottom left and right**—In nature shots, we can shoot in direct sun for many of the images, but we still need to think about the direction of the light and position our camera for the best advantage. It really pays to learn how to meter properly.

Though working in direct sun can pose challenges when it comes to shooting traditional portraits, you can seize the opportunity to create images with a storytelling quality that show your subject engaged in activities they enjoy.

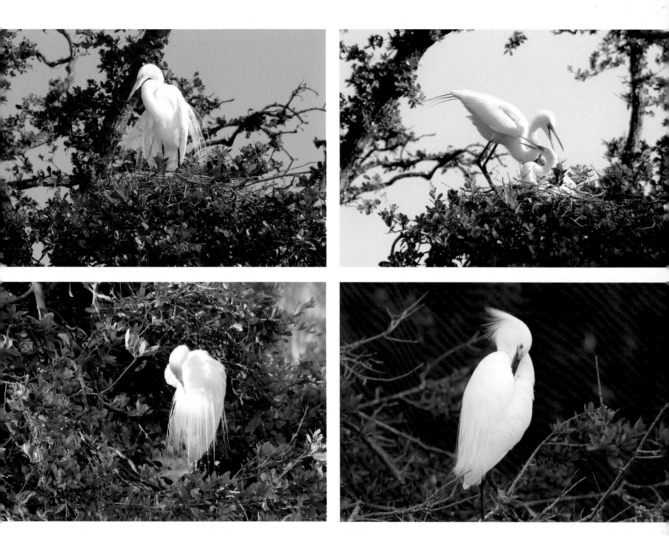

Here are four images that show full sun, partial sun, and full shade. When photographing this subject, the main concern was not blowing out the whites and losing the detail in the bird's feathers. To retain detail in the whites, you need perfect exposure. There are several ways this could be done: you could take a spot meter reading on the white bird and open up your exposure by $2\frac{1}{3}$ stops, use an incident light meter to measure the light striking the subject, or take an exposure reading using the meter's averaging mode and use exposure compensation to finesse the exposure and ensure you have detail in the whites.

NIGHT PHOTOGRAPHY

Night shooting is one of my favorite available light situations. With the high ISO capabilities of the modern digital cameras, this is even more fun. If you do find noise in your night shots, you can use Nik Dfine 2.0 to remove it. It's a great product. Another way to prevent noise is to shoot with your camera on a tripod. Using a tripod will allow you to use a slower shutter speed, which will allow you to use a lower ISO. Remember, the lower the ISO, the less likelihood you will have noise in your image.

Facing page—This shot was made at ISO 6400 @ f/4 and $^1\!/_{400}$. This is how the image looked, straight out of the camera. I love my 5D MK II. There is almost no noise! I used the high ISO because I was doing a lot of different scenes, some that required the high ISO. Because there is a lot of neon and reflection, the center-weighted metering mode worked great! **Below**—I love shooting at dusk. The blue sky added dimension in this image. Exposure: f/4 @ $^1\!/_{60}$ and ISO 800.

Facing page—(top) I was all set to do beautiful cityscapes from the observation deck, but the fog and smog had other ideas, so I tried something different. This silhouette makes for an interesting image. Make sure you turn the subject's body so you can see the outline of their form. Present the subject's face in a perfect profile. To do this, make sure the face is perpendicular to the camera. Try not to let the body merge with any solid elements in the photo (like the window frames). (bottom) For this image, I used the spot meter on the sky. There were so many tones in the building that I chose to expose for the sky and let the exposure for the building go where it would go. I used the cloudy white balance preset to make the sky extra blue and render the building more copper. Exposure: f/3.5 @ 0.4 seconds and ISO 400. (Of course, I used a tripod.) **Top**—If you use the spot meter on your camera, make sure you read something that is midtone. I metered on the background and watched the light on the woman's face. Exposure: f/4 @ $^1/_{30}$ and ISO 1600. **Bottom**—Watch for fabulous photo opportunities as life unfolds. I was shooting fireworks, looked around, and saw this reaction. The exposure was f/4 @ $^1/_{10}$ and ISO 1600. Thank goodness for RAW files. I dragged this out of a dark, very warm image.

METERING FOR NIGHT SHOTS

Metering is the most complicated part of shooting at night. I usually start with the meter in center-weighted mode, especially if there is a lot of black sky. I then center the meter on the lightest area of the scene. You can use the matrix or evaluative mode if the scene you are photographing has a lot of midtones or does not have a large solid black area.

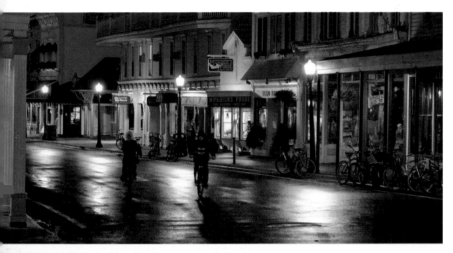

I got up really early one morning while on Mackinaw Island because I knew they washed down the streets every morning and wet streets are great for night shooting. The first image was shot at f/4 @ 1/8 and ISO 2500. Even though the people are on bicycles, I was able to stop the action by waiting until the cyclist drove straight toward the camera. While walking along the harbor, I saw these lights on the pier. I loved the sky (to the eye, it was solid black). I needed a subject and no one but me was awake, so I volunteered! The exposure was f/4 @ 3.2 seconds and ISO 2500. I took a couple of shots, and this was the best one. *(Note:* I tried to hold very still as I shot, and I found that if I let all of the air out of my lungs, I could better hold still.)

Top—Here is a typical night scene with fireworks. I did not have a tripod or even a place to set the camera. This was a $^1/_{50}$ second exposure. Because I could not capture several bursts, I chose to go another direction (see page 97)! **Bottom**—I am not sure if this qualifies as available light, but the flashlight I used *was* available! I used a Black & Decker 2 Million Candle Power flashlight and my Canon 5D on a tripod to photograph this motorcycle in the dark. Exposure: f/22 at ISO 100. The shutter speed was set to Bulb and the shutter remained open for 24 seconds. We turned the lights on the motorcycle for about 5 seconds, then I "painted" the motorcycle for about 20 seconds. I even went behind the bike, pointing the light toward the camera, and painted the tire and the ground. Painting with light is fun to do, and it isn't as hard as it looks. Because the exposure is so long, there is a lot of exposure latitude.

THE MAGIC OF DUSK/DARK PHOTOGRAPHY

BY TONY L. CORBELL

Sweet light. Magic light. Whatever name you give it, we all know it is that time of day when the sun's light begins to fade and the night starts to fall. The lights begin to come on in buildings and homes, and it can be a spectacular time to take pictures. Sure, shooting at this time requires patience and an eye for detail, but when you balance everything just right, the pictures come to life.

At this time of day, the light drops dramatically over just a few short minutes' time, and before you know it, your session is over and night falls. Since time is of the essence, it's a good idea to take extra cameras in order to keep up with the rapidly changing light.

SCOUTING THE LOCATION

Before you take a shot, be sure you have scouted your location and that no annoying bright lights will appear in your frame. A bright security light aimed at your camera can turn a nice picture into an average one. Also, keep an eye on any people in your pictures. During long exposures, people may move. Of course, that swirling effect that results from their movement can also be exciting.

EXPOSURES

Shooting at this time of day can be tricky. It is a good idea to test your exposures and make any brightness adjustments as you shoot, rather than in postproduction. You should, however, make a mental note of anything you may want to enhance later.

There are several ways to establish the right exposure for your image when shooting at this time of day:

- Consider using your camera's spot metering mode. Measure the light in an area of the sky that appears to be 18 percent gray.
- Using a handheld meter in the incident mode is almost impossible in this scenario, but you can certainly use the spot metering mode (see above).
- You can try a technique called the Rule of Ones, which I learned from a friend and fellow photographer, Bob Gallagher. As a starting point, try an exposure of f/11, one second, and ISO 100. You can go lighter or darker to suit your tastes or the subject brightness.

HELPFUL STRATEGIES

Remember the basic techniques we all learned when we started out. A sturdy tripod is essential. I love to work with a quality ball-head outfitted with a spirit level. Also, a locking cable release will come in handy for exposures when the shutter speed is set to Bulb. A small Mini-Mag flashlight will come in handy since it is always dark when you finish shooting this type of work.

Also, try to remember the basics of composition. Usually, there will be a horizon line of some

type in your picture. Be sure you place it in the frame where you know it will generate interest and create drama. If there is water in the scene, make sure its lines are straight and horizontal.

COLOR BALANCE

For a picture with color that looks true and correct, try using a daylight color balance. This will make the sky look normal, and it might warm up the buildings and foreground. For a more stylized look, use the tungsten white balance preset.

This will add a cool or blue look to the image and can create drama. Your personal aesthetic comes into play when determining whether or not your color balance is "right."

There are so many ways to work with this beautiful light. Again, the time goes by quickly. Sometimes the light is gone in only three or four minutes. This requires that special attention must be paid to focus, camera movement, etc. After all, your next shot at a picture like this won't happen until tomorrow.

If you know it will be hard to hold the camera still, then embrace the fact—move the camera on purpose. Shake the camera, zoom the lens, and have some fun. Exposure: f/18 @ 2 seconds and ISO 320. Photos by Doug Box.

ARTIFICIAL LIGHT

Artificial light is described as any light that does not originate from the sun. Tungsten lightbulbs, electronic flash, flashlights, etc., are all considered artificial light. Because this book is about available light, I am going to devote most of the discussion to working with existing artificial light—the kind you discover when you arrive at a location, not the photographic lighting units you might find in your gear inventory.

Working in varied lighting conditions is much easier with digital than it ever was with film. I find myself photographing in some very unusual lighting situations and not adding any flash. It is a lot of fun and it is simple: just take a custom white balance or shoot RAW and include a white card or target in the shot, and you will get results that work.

Facing page—For this image, I used my Wescott TD-6 constant lights in a 4x6-foot Westcott softbox placed at camera left, a 1x4-foot striplight above and behind the subject, and a silver reflector placed at camera right. This is a studio light that uses Westcott 5000K compact fluorescent screw-in lightbulbs to create a daylight-balanced light. **Above**—This was one of the images that came to mind when I decided to write this book. When I saw this scene, I envisioned this image with my favorite model—my wife—and this outfit! I used the available tungsten lamps and spotlights. I did point one of the spotlights away from the painting and onto the subject. Other than that, I simply posed the model and metered the scene.

Above—Take advantage of the light that is there. While photographing a wedding, I noticed this spotlight near the piano. I positioned the subject near the edge of the instrument and tilted her face until the light was right and she had catchlights in her eyes. I did a fun little pose, tilting her shoulders to add flow. I couldn't get the color balance right, so I used Nik Silver Efex Pro 2 and converted the image to black & white.

Top—It is almost easy to make great photographs of interesting subjects in beautiful places. To create this image, I used my Canon 5D MK II, fitted with a 24–105mm f/4 Canon lens set at the 35mm focal length. To keep from getting distortion in my subjects and the background, I kept the camera perfectly level and positioned the subjects' faces in the center of the frame. Exposure: f/4.5 @ $^1/_{15}$ and ISO 800. **Bottom**—While teaching a photo class on a cruise ship, I was looking for a great place to photograph this beautiful model. When I saw this statue, I realized I'd found my spot. I simply placed the subject in the perfect spot and worked with the available light to make the exposure. Since I could not move the light, I raised her face until the light was in her eyes.

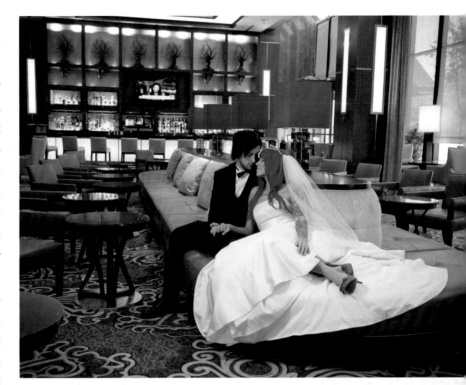

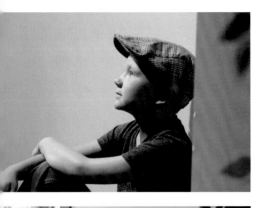

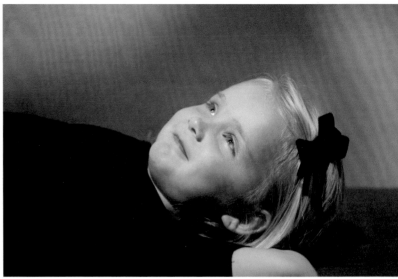

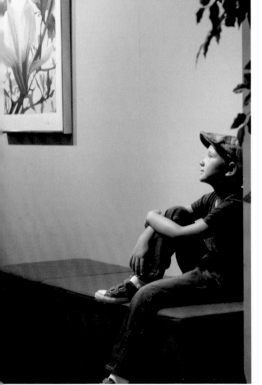

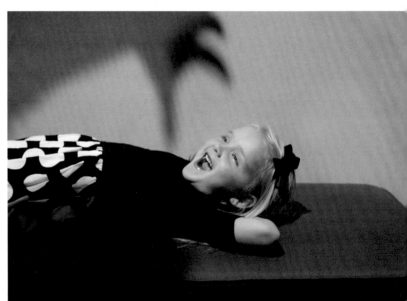

While photographing these two adorable children outdoors, we ducked into the foyer of a building to escape the heat. I noticed the spotlights pointing down at the red bench. All of these images were shot at f/4 @ $\frac{1}{10}$ second and ISO 200, on a tripod. In the last photo (bottom right), I chose to have a little fun with the subject.

All three of these shots were done the same way. I started with the tungsten white balance preset and set the meter to the evaluative metering mode, then made slight adjustments in-camera with the exposure adjustment button. I will admit, when shooting snapshots on vacation, I tend to use the evaluative metering mode, look at the back of the camera, and adjust the exposure accordingly. However, I never use auto white balance. I have found using the presets, shooting RAW, then making adjustments to color on my computer—rather than in the field—to be a more effective option for me.

Above—This image was illuminated with one lightbulb. It was shot at f/5.6 @ $^1/_{60}$ and ISO 1600. Almost all of the images in this book are SOOTC (straight out of the camera). I wanted you to see exactly what I am capturing—without using Photoshop. The first image shows some noise, which is especially visible in the shadow areas. I used Nik Dfine 2.0 to reduce the noise and used the Fill filter in Camera Raw to bring up the midtones. The results are shown in the second image. **Facing page**—Using the overhead lights in the hotel, I moved the bride and my camera so that the light on her face was in the correct position.

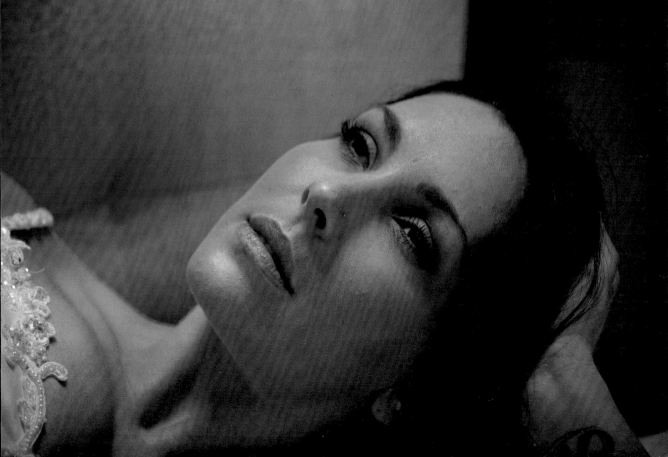

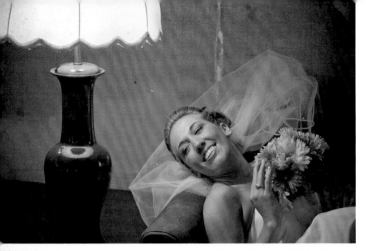

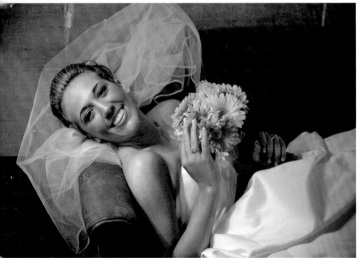

Top—As this setup shows, I used a simple table lamp to light the subject in this series. All three images were shot at f/4 @ $^1/_{10}$ and ISO 100. **Center and bottom**—Look at the difference between these two images. Both are nice, but to me, the light in the subject's eyes is better in the black & white photo. I had moved the camera to a position where the light was shining into her eyes. To me, that made a huge difference.

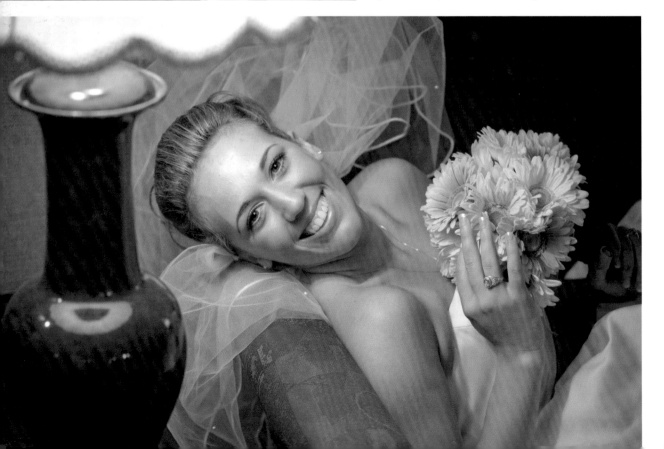

Be aware of the light around you! I taught a class at the New England Institute of Professional Photography in Hyannis Port, Massachusetts. While I was walking around my hotel, I noticed this scene, so I had one of my students sit in this chair and made an image with a photojournalistic look. Exposure: f/4 @ $^1/_{100}$ and ISO 1600.

Top left and right—This image was made using the incandescent track lights in my studio. I like the Hollywood-style hard light they produce. I positioned the model to get some shadows from her lashes, took a reading with my handheld incident light meter, and created the image. Exposure: f/7.1 @ $\frac{1}{40}$ and ISO 4000. There was a lot of noise in the original image (left), so I used NIK Dfine 2.0 to remove it. **Bottom**—While teaching at the New England Institute of Photography in Hyannis Port MA, I noticed the beautiful light on the woman at the registration desk. I had her raise her face to the light, then I metered the light striking her face and took the image. Available light is everywhere, so keep your eyes open!

SPECIAL APPLICATIONS

SILHOUETTES

I find that silhouettes make striking and dramatic photographs. When viewing art, your eye typically goes to the part of the image with the most contrast or the brightest area. When you photograph a silhouette, you almost force the viewer to look where you want them to look because most of the image is black or almost black (there is, therefore, inherent contrast).

I remember, as a young child, sitting for a woman who had a booth at Disneyland. She cut my silhouette out of black paper with a set of tiny, sharp scissors. She made a silhouette of my sister too. I was fascinated because you can actually recognize us from those silhouettes. I've never forgotten that. When I began my career in photography, I was always intrigued when my silhouette photographs worked!

When creating a silhouette, there are many things to consider:

- *Ensure that your image tells a story.* The stronger the subject, the stronger the story and the more recognizable the subject will be. Look at this wedding silhouette. Cover the bride, then cover the groom. Which shape is stronger? For me, it is the bride. There are a few reasons why this is the case. First, she has more shape! Second, the partially see-through veil helps tell the story. Third, the little bit of light on her shoulder and chest gives her more definition. Finally, she is more isolated from the background than the groom.
- *Isolate the subject.* Try to keep the subject from blending in with the background. Sometimes

Right—To create this silhouette, I metered the background, posed the couple in the doorway (to keep light off of them), then used the manual setting on my camera to lock in the exposure.

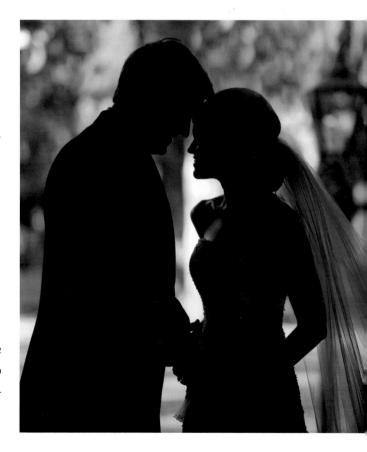

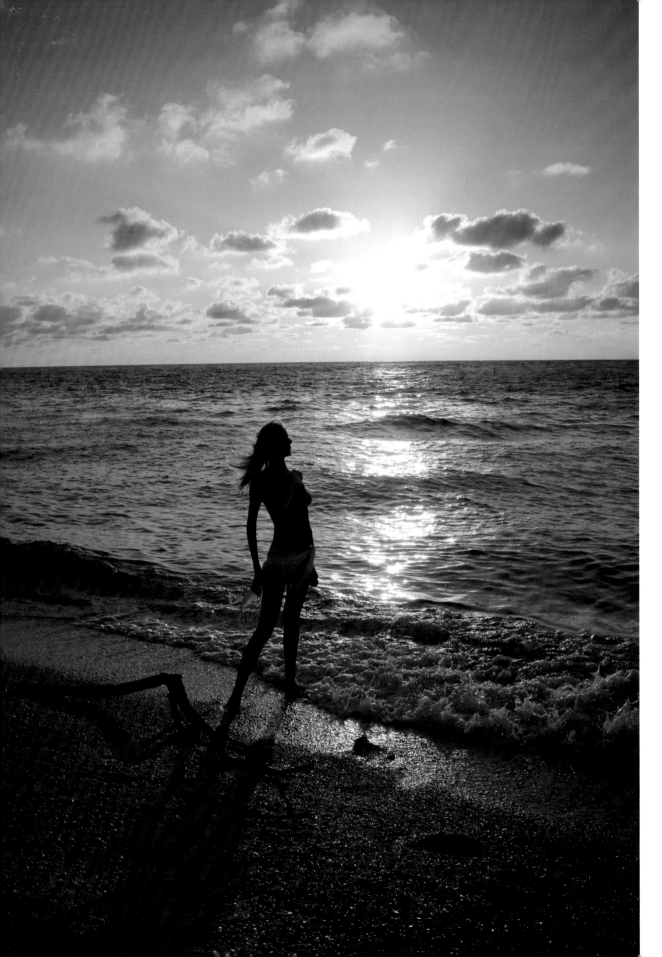

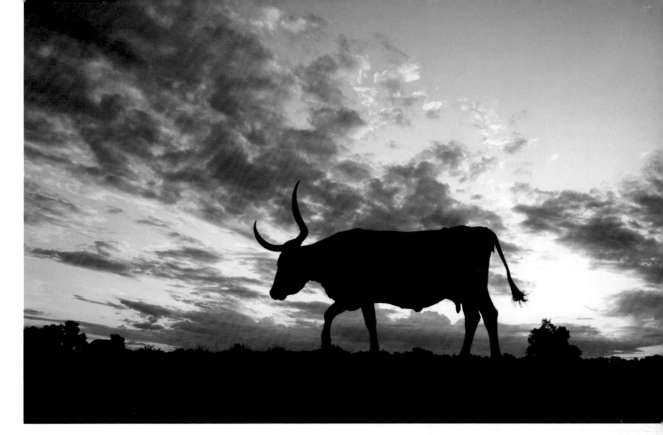

Facing page—As I started to study photography and experiment with different styles, I developed a system for making great silhouette images. My favorite part of these images is the bit of mystery they create. Silhouettes leave some of the story to the viewer to interpret. In some images, no further information is necessary. **Above**—When shooting silhouettes, isolate the subject for the best-possible image presentation.

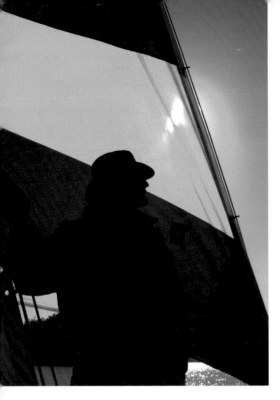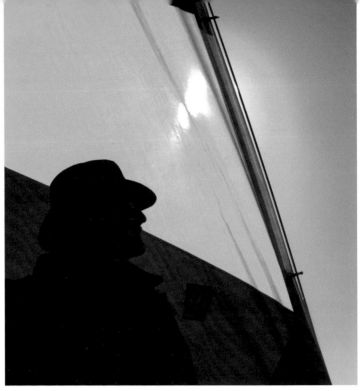

Above—In this image, there is a great level of contrast between the subject and the sail. This helps to focus the viewer's attention on the subject. The first image is fine, but I liked the cropped version better, as I was able to eliminate some of the distracting elements in the image to draw the eye to the focal point of the image. **Facing page**—(top) For this image, I used a spot meter to meter the background. I chose to meter the green reflection above the gentleman's head (a midtone) to give the background a more real look. Metering the bright area on the water would have resulted in a recommended exposure setting that would have produced a darker overall image. I experimented with the auto setting on the camera and, surprisingly, it gave me a very similar exposure. The evaluative setting on my Canon 5D MKII is amazing. Remember to make sure your flash is turned off! (bottom) Create maximum contrast (at least a three-stop exposure difference between the silhouetted subject and background) for an image that pops.

a lower camera angle or simply shooting from the ground will accomplish this, as it did in the photos of the longhorn and the truck and kayak (page 111).

- *Meter the background.* Sometimes there is so much black in the scene that if you use an averaging or center-weighted meter setting, the meter may be fooled and recommend an exposure that will overexpose the silhouette.

- *Have at least a three-stop exposure difference your subject and your background.* One of the easiest ways to do this is to have your subject indoors, against an outdoor background (as is the case in the image of the man in the bar). Alternatively, you can shoot into the brightest area and have your subject in front of that bright area (see the image of the man and the boat's sail).

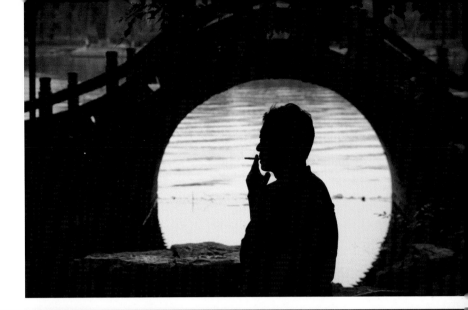

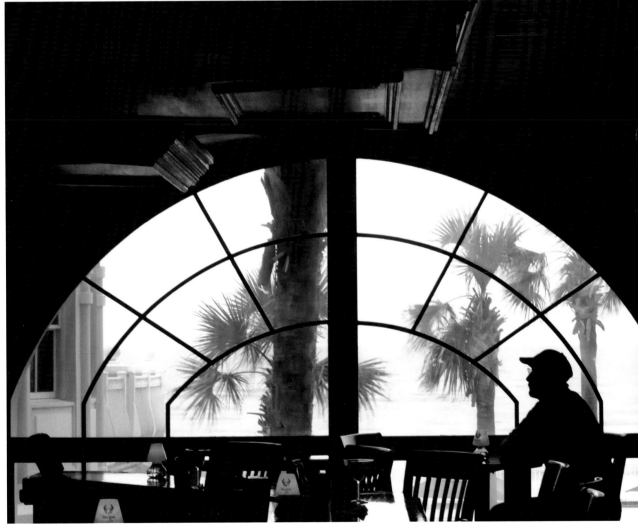

Compositing Silhouettes. It is easy to combine silhouettes with other images in Photoshop to create a different story. The image below is comprised of three images; each was shot on a different day and in a different location. With the power of Photoshop, I was able to create a believable image.

This composite silhouette image was made from three image files. I simply used Photoshop's Magic Wand tool to select the black tones of the silhouetted subjects and combined them, creating a new reality.

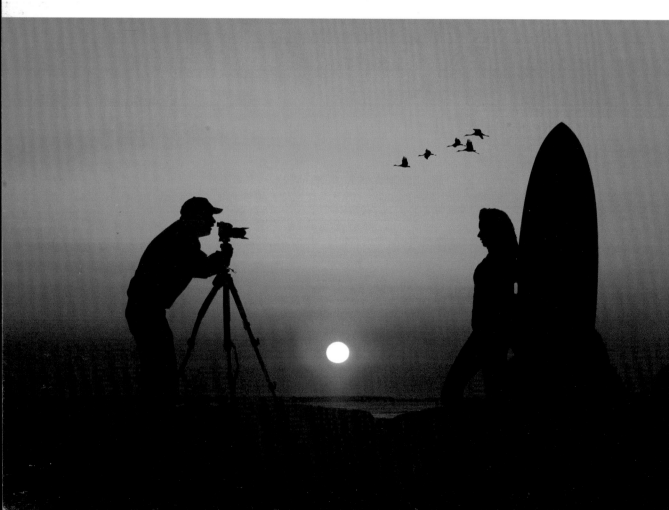

Top—A long exposure of $\frac{1}{2}$ second gave the water a soft, flowing look. This is the full image. I have cropped the image in several different ways. Each cropping produced a totally different feel. **Bottom**—Being at the right place at the right time, with the right lens on your camera, ready to go can certainly result in a great photograph. Early one morning, while staying at the Ghost Ranch, I went out shooting. As I topped the ridge, I saw my coyote friend. The Canon 7D was equipped with the Canon 400mm f/5.6 lens and Canon 1.4 extender. The final exposure was f/8 at $\frac{1}{640}$ second and ISO 500.

NATURE AND WILDLIFE PHOTOGRAPHY

When it comes to shooting in available light, nature and wildlife subjects are among my favorite. In these situations, you typically can't control the light, so you have to scout out the area and plan for the right time of day, or simply wait until the light is right. Sometimes, you just get lucky. For a very dramatic image, I recommend shooting as the weather is changing—for instance, as a storm begins or when it is winding down.

I call this image *Clearing Storm*. When I saw the storm clouds while shooting in the Ghost Ranch area of northern New Mexico, I decided to wait out the storm and hope for a great moment with unusual weather. Shooting when the weather is changing can make for excellent images.

Facing page and right—Time of day is one of the most important aspects of available light nature photographs. Another critical consideration is composition. You can see how all of the lessons we have learned about creating portraits—finding great light, using light with direction, and choosing an aperture and focal length that deliver the desired depth of field—come into play when shooting nature images.

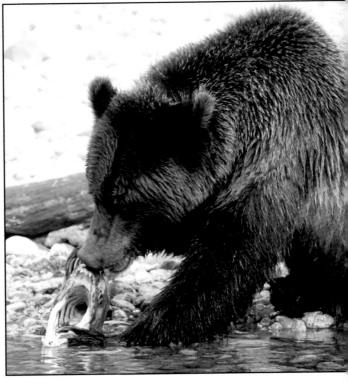

These images were shot with a 400mm lens. You can see the difference between the photographs done in bright sun and softer light. Keep depth of field and light direction in mind when photographing outdoors. You certainly can't ask the bear to move or turn its head, but you can have patience and wait for just the right moment.

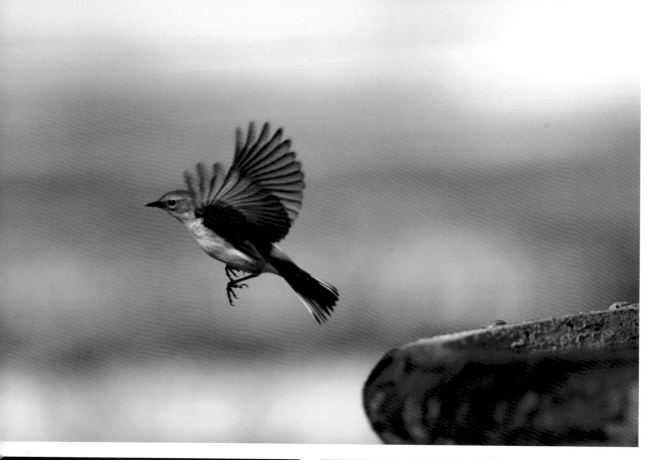

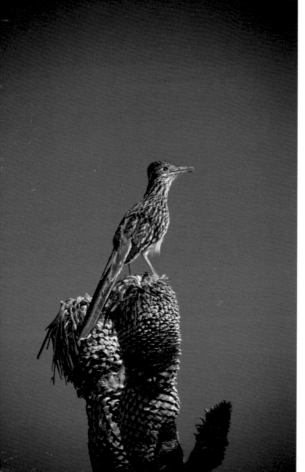

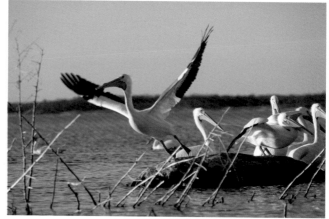

Shutter speed is important to nature and wildlife portraits. I shot the first image at f/2.8 @ $1/2500$ second and ISO 320 to try to stop the action of the bird flying. When I was shooting the second image, the road runner was completely still. I was able to use an exposure of f/11 @ $1/100$ and ISO 100 and get the shot. The final image was shot at $1/800$. Pelicans flap their wings much more slowly than small birds do.

TRAVEL PHOTOGRAPHY

I love travel photography. I really enjoy visiting exotic locales, where I am free from the hassles of everyday life and have the time to create beautiful images.

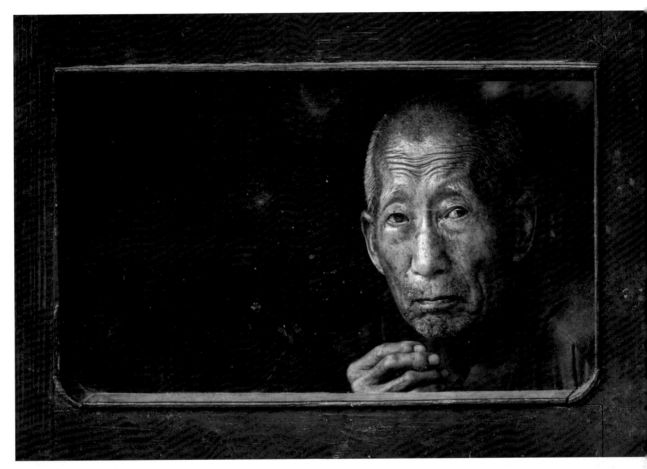

While teaching in China, I was riding on the back of a three-wheeled motorcycle taxi. It was early, and the light was relatively low. As we were driving through the streets of Pingyau (I was riding backward in the scary machine), I looked over my shoulder and saw this gentleman looking out the door of his small home. I quickly captured two shots. I was lucky to get one image that was sharp. Occasionally, I want someone else's opinion on my work—someone to share their vision with me. Master printmaker Jonathan Penny (www.jonathanpenny.com) from New York is such a person. It is fun and exciting to see what someone else sees in my original image. I gave Jonathan a few ideas as to what I wanted, and he did the rest. Some people like to do their own postproduction work. I enjoy doing some of it, but I also enjoy having a master printmaker do some of the work. I think Jonathan did an amazing job.

Top—While driving through the countryside in southern China, my friend and I stopped at a brick factory. We wandered around, making some fabulous images. A light rain began to fall, so I jumped into our van. I was looking at the man sweeping through the raindrops. I chose to focus on the window and let the man fall out of focus. Because of the difference in distance from the camera to the window and the camera to the subject, an aperture of f/9 gave me the depth of field I wanted. **Bottom**—China has a remarkably diverse culture, from the hustle and bustle of the big city to the poverty seen in the small towns. I saw this young girl step out of her humble home, look at me, then slip back in. When traveling, be ready to capture a moment. You may not get a second chance to get that great image.

Top—I love to get up early while traveling. I stayed at a beautiful resort on Dominica called Rosalie Bay. The resort is on a beautiful black-sand volcanic beach. The exposure for this image was f/4.5 and $1/1600$ and ISO 400. The focal length was 22mm. Placing the subject dead center in the frame is usually a compositional no-no, but it works in this image. **Center**—A few minutes later, I was presented with this situation. Wow! Beautiful color, dramatic waves, a glorious sunrise. I increased the saturation in Camera Raw to bring out the incredible color. **Bottom**—You cannot count the number of bicycles in Italy! Earlier in the book, I talked about the twelve elements of a merit image. How many of those elements do you think this image covers?

Above and left—I love open markets. While in Italy, I created a collection of images of vegetables. Photos like these make great kitchen decorations. The exposure was f/5 at $1/160$ and ISO 100. The focal length was 96mm. **Facing page**—In Ireland, they assume you know it is dangerous to stand near the edge of a cliff. They reason that a sign and a rail will do you no good if you aren't bright enough to steer clear of such danger. This faith in the public means you can take some spectacular photos of scenes that are not obscured by rails, fences, signs, and guards.

Above—The locals are one of the best parts of traveling to foreign lands. This fellow was driving a horse and buggy. What a great face! When I first began photographing people on my travels, I used to try to sneak photos. Now, I try to engage them in conversation, ask about their lives, and try to get their permission to photograph them. When you are respectful, you will find that people often do not mind having their pictures taken. The exposure for this image was f/13 and $^1/_{200}$ at ISO 800. The focal length was 189mm.

Left—I spoke to this street vendor for a while and even bought an image from him—then got permission to photograph him. I used my Canon 70–200mm lens at the 200 end. The exposure was f/6.3 at $^1/_{500}$ and ISO 640.

Top and center—While photographing on the island nation of Dominica in the West Indies for a World Photographic project for the Peace Corps and Hands Across the Water, I came upon these cute kids playing in their neighborhood. When you look at the pull-back shot, you see how different things are for kids in other parts of the world. As you can see, though, the kids were happy and having fun. **Below**—During my trip to Venice, I saw several beggars. It was hard to look at them kneeling for hours at a time. There were several others surrounding this woman, but isolating her made for a stronger image. I didn't get her permission to take the image, but I did make a donation. The exposure for this shot was f/6.3 at $^1/_{500}$ and ISO 640. The focal length was 200mm.

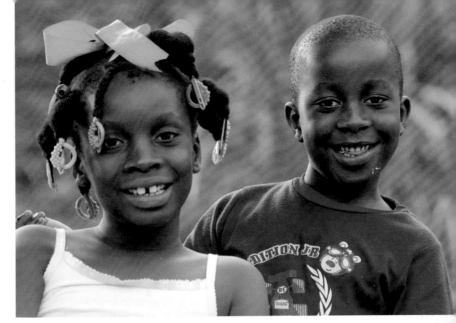

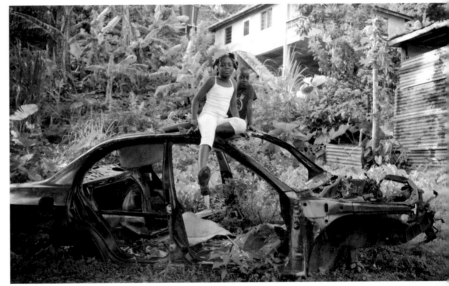

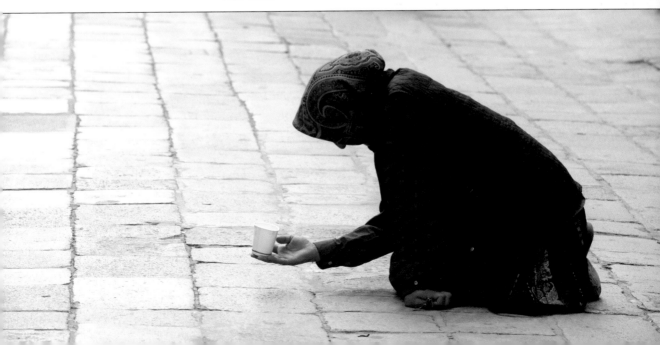

SPORTS PHOTOGRAPHY

Long lenses, fast shutter speeds, and monopods are essential for sports photography. If you'll be shooting at night or in low light, using a high ISO will be critical. The lens length required will depend on the type of sports you will be photographing. For field sports, my favorite lens is the 300mm f/2.8. It is long enough to reach out and capture the action in the middle of a field, and with its wide f/2.8 aperture, you can use a fast shutter speed. As you become more adept at photographing sports action, you will want to use longer and longer lenses. (*Note:* Using a longer lens makes it more difficult to find the action when looking through the lens.)

I have found that shooting in aperture-priority mode works well for me. Many folks are surprised by this. They assume that shooting in shutter-priority mode would be better, as they could choose the "right" shutter speed. The fact is, when you shoot in aperture priority, the camera will choose the highest possible shutter speed available for the given situation. Using aperture priority mode is especially helpful in high school football stadiums, as the light seems to be surprisingly bright between the 20-yard lines but falls off in the end zones. One of the worst lighting situations arises when you are standing in the end zone and photographing

Using aperture-priority mode is especially helpful in high school football stadiums.

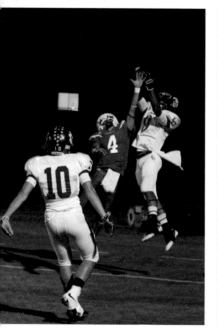

In this situation, I was faced with an image with too much noise because the shot was slightly underexposed and I cropped the full-frame image tightly to improve the composition. The image on the far right shows the result after applying the NIK Dfine 2.0 Noise Reduction plug-in.

Above—This cool shot would not have been possible with a low ISO. The exposure was f/4 at $^1/_{500}$ and ISO 6400. The focal length was 75mm.

players coming toward you, as the light is also coming toward you.

At night, I tend to push the limits of my camera's ISO range. ISO 1600 is a starting point, and I go to 6400 on a regular basis. If the image is a bit underexposed, noise and grain can be a problem. I tend to use an aperture range of f/2.8 to f/4 at night; that allows me to use a shutter speed that is fast enough to stop most action.

As I mentioned, a monopod is essential equipment for sports photography. It steadies the camera, eliminating camera shake. I have used a tripod in situations where a lot of movement wasn't required; if you choose to do the same, be sure that you are very familiar with your tripod controls.

You may find it easier to use a monopod when shooting sports photography. Using a monopod will allow you to rely upon your arm and shoulder muscles a little less when you are shooting with a big, heavy lens. Finally, the monopod serves as a handle of sorts. You can throw the lens over your shoulder when changing positions on the field.

Box

I am experimenting with a device called a Steady Pod. It is a kind of reverse monopod. You attach it to the bottom of your camera, extend the small cable to the ground, step on a tab at the ground to hold the cable in place, and pull up on your camera. The tension that is created in the length of cable keeps your camera from moving up and down.

Facing page—Shooting sports photos outdoors during the day is much easier than shooting outdoors at night or photographing indoor sports. When shooting during daylight hours, the hardest part is anticipating where the action and the sun will be. Many times, the sun will be behind the subject, meaning his or her face is dark. I made this sports poster for my youngest son when he was playing soccer. I combined five images in Photoshop. **Left and right**—Both of these images were taken at a 300mm focal length. The image on the left was shot at f/4. The photo on the right was made at f/3.5—almost the same aperture. Still, there is a huge difference in the depth of field. Why? Depth of field is determined by three factors: (1) the aperture, (2) the focal length of the lens used, and (3) image size and its relationship to the subject distance.

Top—You need to use higher ISOs in low-light scenarios. This image was shot at f/2.8 @ $^{1}/_{200}$ and ISO 1250. I rented a 300mm f/2.8 lens from www.lensprotogo.com. The difference between the f/2.8 and the f/5.6 that most people have is two full stops. In the scene shot here, you would have had to shoot at f/5.6 @ $^{1}/_{50}$ second or increase your ISO to 5000. In a situation like this, a fast lens is very important. **Bottom**—You don't have to be on the field to make great shots. I was in one

of the box seats when I captured this shot. The biggest problem in shooting from there is that you cannot move, so you're limited to capturing action that unfolds at this end of the field. When you look at this image, you will notice a colored blob in the lower-left corner, at the player's feet—there were people on the field who kept getting in the way. I typically use aperture priority mode when shooting sports. I advise new shooters to use auto ISO if the stadium they are working at has a fairly low light level. It will force the camera to use the highest ISO available for the situation.

Below—I used aperture priority mode and ISO 800 to create this photo. I'd borrowed a Sigma 120–300mm f/2.8 lens from a friend. I shot at f/3.5 for a little extra depth of field because the action was unfolding so fast and following it through a 300mm lens is tough for a new sports shooter. By using aperture priority, I forced the camera to choose the fastest shutter speed possible for the lighting situation. In this shot, the shutter speed was $^1/_{1600}$. Another reason to use the automatic setting was that the exposure was constantly changing because the clouds were coming in and out.

Both of these images were shot at $^1/_{80}$ second and f/4 at ISO 800. The difference between the images is subject motion. While at the national rodeo finals one year, I was playing with motion and slow shutter speeds. In these images and the following, you can see how action and slow shutter speeds can create fun and interesting images.

Both of these images were shot at $^1/_{15}$ second and ISO 100. The first image was made in the middle of the motion, while the horse was moving the most. The second image was made at the peak of the action.

WORKFLOW

There is no one-size-fits-all workflow in photography. There are as many workflow systems as there are camera models and photo specialties.

In my mind, having a workflow in place is insurance that you don't leave out a critical step in the postcapture process and put yout images at risk. In this chapter, I will outline the workflow that works for me.

RAW *vs.* JPEG

I guess the first step in the workflow is to determine whether you should capture your images in RAW, JPEG, or both. For most of my photography, I shoot RAW. I want the freedom to adjust my files in postproduction without any of the image degradation that can happen in JPEG. More important still, RAW software is constantly getting better, and I want the option to go back to my RAW files at any time in the future and reprocess them with the latest, greatest software available. Shooting in RAW also allows me to quickly make adjustments to color temperature and exposure inconsistencies (though I don't have to do that much because I use a handheld meter). It also ensures that I can quickly run a batch process to convert files to different size JPEGs, rename files, and so much more.

I would shoot in JPEG format only if I were working in a completely controlled situation where the light would not change. If I was shooting a job with studio lights, did not have to reposition the camera or lights for any shot, and the job required only small prints, JPEG would suffice.

I used to shoot JPEG on vacation—I figured I was just taking snapshots—but I kept making a few really great images on vacation and would inevitably wish I had shot in RAW, so now I opt to shoot in RAW even then. There are people who only shoot in JPEG, and for them it is right, and that is ok. For me, RAW is the best option—even if saving the larger files requires more disk space.

TRANSFERRING THE FILES

When the memory card in my camera is full, I use a card reader to transfer the RAW files to my hard drive. I make a folder—or multiple folders—and drag the images to the appropriate place. Next, I use Time Machine (in the Mac OS X Snow Leopard operating system) to back up my hard drive.

Next, I go through my RAW files using Adobe Bridge, then convert the files using Adobe Camera Raw or I will use Adobe Lightroom. How do I choose? If I just just want to scan through the catalog of images and convert a couple to JPEG, I use Camera Raw, mainly because I have used it for a long time and am comfortable with it. If I have a lot of images to process and have the time to change my metadata, add tags, etc., I will use Lightroom.

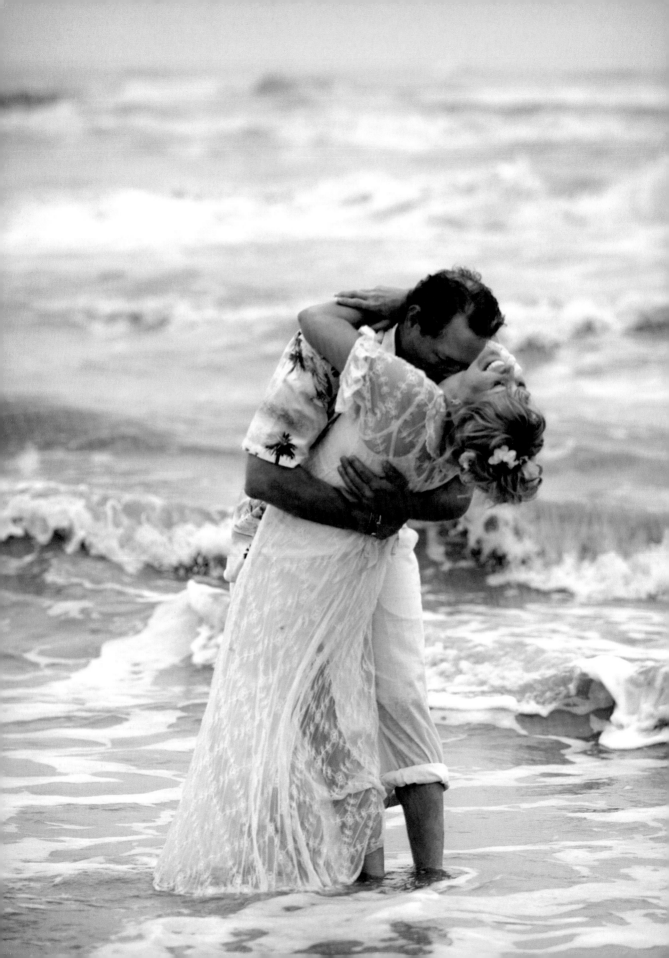

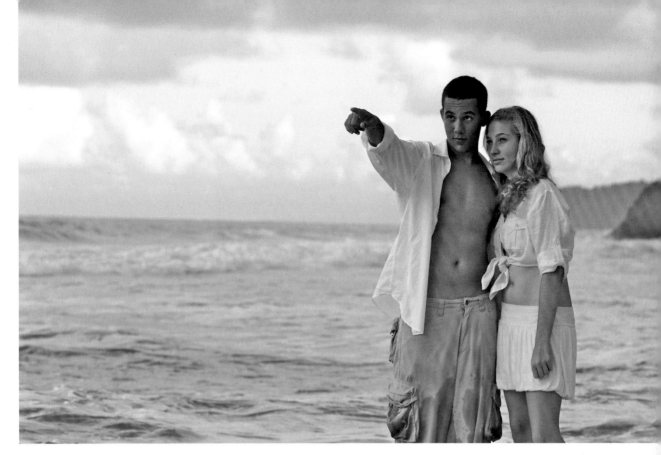

Facing page—Developing a workflow and consistently using the steps you've outlined can help you to safeguard your clients' precious images. **Above**—Without the costs associated with film and processing, photographers shoot more images than ever before. Be sure that you have a print of your images on file—technology is always changing, but printed images have staying power. Photo by Randy Kerr.

BACKUPS

At this point, I burn a CD or DVD of the shoot and store it in my filing system. (These files are arranged alphabetically, by the client's name, to allow for easy retieval.)

With all of the image files safely stored in three places, I format the card.

Never use your computer to erase the files on the card.

Formatting the Memory Card. Never use your computer to erase the files on the card. Instead, format the card in your camera.

Camera techs have told me that I should not use the trash can option to erase the image files. They've explained that when you use that approach, the file directory is erased and the camera has to write over the files—because the files aren't really erased. To be honest, I still use the trash can option occasionally—when I am at

Left—Capturing images in RAW format is, for me, the way to go. The files contain more visual information which, for me, is worth the disk space that storing the format's larger files requires. **Facing page**—There are times when a reshoot just isn't possible. Don't risk losing your images by taking workflow shortcuts. Always back up your images in multiple locations. Photo by Randy Kerr.

the end of the card and just need to take one or two more shots—but I do not make it a habit.

PRINTING IMAGES

I always print my images. With digital photography, photographers capture more images than ever—but relatively few of them are ever printed. I have a feeling that, in thirty years, our grandkids will be looking for all the photos we said we took, but they won't find them. Technology will have evolved and the iPhone will be dead, the computer and hard drive will be long gone, and no one will have access to a CD or DVD reader. Create hard copies of your images. Prints have endured the test of time.

Create hard copies of your images. Prints have endured the test of time.

Digital photography is supposed to save us time and money. Unfortunately, too many of us spend too much time in postproduction due to an inefficient workflow. Let's look at some of the ways we can turn that around.

EXPOSURE CONTROL

Getting a perfect exposure at time of capture is critical. The way to make this happen is to use a light meter. If you stop relying on your LCD screen to gauge your exposures and start using a light meter again, you can capture accurate exposures in the vast majority of situations. Now, it certainly isn't practical to use a meter while running around after the bride at a wedding, but in a controlled shooting environment, you should use it every time. Remember that with digital,

Photo by Tony L. Corbell.

you have an exposure latitude of approximately $^1/_3$ of a stop; this means that you can over- or underexposure the shot by about $^1/_3$ of a stop and still have a full range of tones, without blown out highlights or blocked up shadows. *(Note:* If you are shooting in RAW, you have more leeway, since you can make exposure adjustments to these types of files, but the name of the game is saving time—and money.)

MONITOR CALIBRATION

With digital, we no longer rely on our lab to ensure consistent, accurate image color. The critical first step in making color corrections is calibrating your monitor. No monitor comes out of the box perfectly calibrated. You must run monitor calibration software to bring your screen into the correct color and exposure tolerances for most applications. There are several brands and styles of calibration systems available. They range from $250 to $500. They usually come with a device that attaches to your screen and reads the colors and tones represented while the software runs. I recommend profiling your monitor quarterly just to make sure it doesn't drift off of calibration.

COLOR SPACE

Most photographers who are shooting 35mm digital will find that their cameras capture in the sRGB color space. Medium format digital cap-

ture magazines or "backs" capture in Adobe RGB. Output devices use the sRGB or Adobe RGB color space as well.

When you're working in Photoshop, you can select the color space you want to work in via the Preferences menu. If you select the color space that your camera and output device use, you'll end up with a higher quality image file. The sRGB space is smaller than the Adobe RGB color space, so if you were to move, say, from capturing an image in sRGB to printing an image in the Adobe RGB color space, you would need more data (the computer would make calculated guesses to fill in the missing tones). Likewise, if you printed an Adobe RGB image on a device that used an sRGB color space, the data that did not fit in the smaller color space would be discarded, making the file much lower in quality. So, the bottom line here is to simply keep the color space consistent whenever you can. From capture, to computer, to output, always be consistent.

WHITE BALANCE

The transition to digital was not too difficult for commercial photographers, as they have always worked on slide or transparency film—media that gave them full control over color. In the past, wedding and portrait photographers have typically worked with negative film and have had a professional lab to adjust the color in their final prints. Now that they have made the transition to digital, they are responsible for achieving a correct color balance for the scene in which they are working.

In the time I have been shooting digital, I have discovered a few strategies that can help you shave some time off of the color correction process:

- Do not use the automatic color balance setting. Instead, select the appropriate white balance preset for the light you encounter on the scene. These presets are pretty accurate. For example, if you are working outdoors on a sunny day, use the daylight preset. If the sky is overcast and the light seems cool, use the cloudy day preset.

- To achieve the most accurate color balance for true color, use your camera's custom white balance feature and a white card placed in the subject's area. I would caution you against using a gray balance or gray card for setting your custom color balance. "Gray" cards tend be a bit blue or green, you can create a custom balance that is off-color.

- There is a great product on the market called the Wallace ExpoDisc. This incredibly accurate white balance filter slips over your lens, collects light from 180 degrees, and averages it to ensure proper color rendition when a custom white balance setting is required. The ExpoDisc is as accurate as a white card.

Speed and accuracy are the name of the game when it comes to saving time and money in digital photography. If you follow the advice I've provided in these four areas of your workflow, you will be able to spend more time with your family, keep your sanity in check, and ensure your workflow is running smoothly. Oh yeah—and you just might make some money.

CONCLUSION

In the previous chapters, you've gained insight into my working habits—as well as the strategies used by renowned photographers Randy Kerr and Tony L. Corbell. The images that appear on these pages prove that you can create photographs of any subject in any available light scenario once you understand how to see, modify, and harness light.

Having come this far, you owe it to yourself to take what you've learned and put it to use—whether in your living room, in your own backyard, or in indoor and outdoor locations far from home.

I've included some resources that will help you continue your education (see page 145) and grow as a photographer.

Best wishes for your artistic and financial success.

Facing page—Photo by Tony L. Corbell. **Below**—Photo by Randy Kerr.

ONGOING EDUCATION

To learn more about a wide range of photographic topics, see the following web sites:

GOING PRO: FOR EMERGING PROFESSIONAL PHOTOGRAPHERS
www.goingpro2010.com

PROFESSIONAL PHOTOGRAPHERS OF AMERICA
www.ppa.com

PROPHOTOGS: AN EDUCATIONAL FORUM WITH DOUG BOX
www.prophotogs.com

TEXAS PHOTOGRAPHIC WORKSHOPS
www.texasphotographicworkshops.com

TEXAS SCHOOL OF PROFESSIONAL PHOTOGRAPHY
www.texasschool.org

WEDDING AND PORTRAIT PHOTOGRAPHERS INTERNATIONAL
www.wppionline.com

WORLDPHOTOGRAPHIC
www.worldphotographic.org

Facing page—Photo by Randy Kerr.

RESOURCES

CAMERAS

www.usa.canon.com

INFRARED CONVERSION

www.viewfindermasks.com

LAB

www.collages.net

LENS RENTALS

www.lensprotogo.com

MASTER PRINTMAKER

www.jonathanpenny.com

METERS

www.sekonic.com

LIGHT MODIFIERS

www.fjwestcott.com

SOFTWARE

Adobe Photoshop
www.adobe.com

NIK Software
www.niksoftware.com

TRIPODS

www.manfrotto.com

DOUG'S TOOL BOX

Here's a list of the equipment that's essential to my each and every available light shoot.

Canon 5D MKII

Canon 7D

Canon 5D, converted for infrared capture

Canon 70–200mm f/4 lens

Canon 24–105mm f/4 lens

Canon 17–40 f/4 lens

Canon 580 EXII flash

Manfrotto 458B tripod and Gitzo 1376M head

Sekonic L358 meter

Westcott 5 in 1 reflector

Canon XA-H1 3-chip video camera

Contour hd video camera

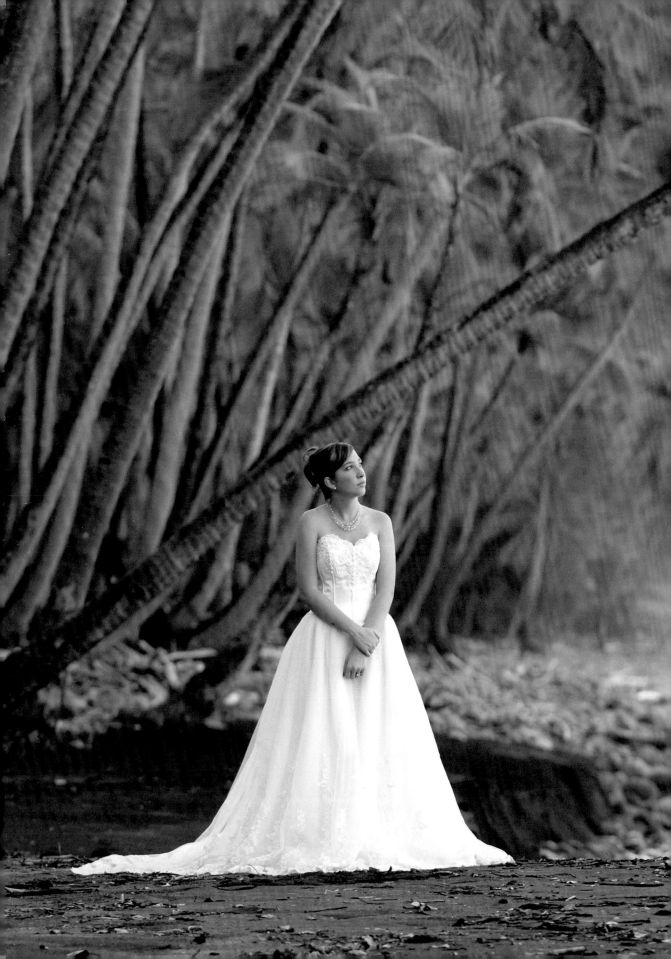

INDEX

Facing page—Photo by Randy Kerr.

Professional Secrets of Wedding Photography, 2nd Ed.

Doug Box provides lighting diagrams, posing information, and exposure info, teaching you the art of wedding photography. *$29.95 list, 8.5x11, 128p, 80 color photos, order no. 1658.*

Posing for Portrait Photography

Jeff Smith teaches surefire techniques for fine-tuning every aspect of the pose for the most flattering results. *$34.95 list, 8.5x11, 128p, 150 color photos, index, order no. 1786.*

PROFESSIONAL TECHNIQUES FOR
Natural Light Portrait Photography

Doug Box's beautifully illustrated book gives detailed instructions on equipment, lighting, and posing natural-light portraits. *$34.95 list, 8.5x11, 128p, 80 color photos, order no. 1706.*

Simple Lighting Techniques
FOR PORTRAIT PHOTOGRAPHERS

Bill Hurter shows you how to streamline your lighting for more efficient shoots and more natural-looking portraits. *$34.95 list, 8.5x11, 128p, 175 color images, index, order no. 1864.*

Portrait Photographer's Handbook, 3rd Ed.

Bill Hurter's popular step-by-step guide leads the reader through all phases of portrait photography. *$34.95 list, 8.5x11, 128p, 175 color photos, order no. 1844.*

DOUG BOX'S GUIDE TO **Posing for Portrait Photographers**

This visually intensive book provides all of the tips you need to pose men, women, children, and groups. *$34.95 list, 8.5x11, 128p, 200 color images, index, order no. 1878.*

Master Posing Guide for Portrait Photographers

J.D. Wacker's classic posing book offers can't-miss strategies for posing single portrait subjects, couples, and groups. *$34.95 list, 8.5x11, 128p, 80 photos, order no. 1722.*

Professional Model Portfolios
A STEP-BY-STEP GUIDE FOR PHOTOGRAPHERS

Billy Pegram teaches you how to create portfolios that will get your clients noticed—and hired! *$39.95 list, 8.5x11, 128p, 100 color images, index, order no. 1789.*

Group Portrait Photography Handbook, 2nd Ed.

Bill Hurter and 100 top pros provide tips for composing, lighting, and posing group portraits in the studio and on location. *$34.95 list, 8.5x11, 128p, 120 color photos, order no. 1740.*

Master Lighting Guide
FOR PORTRAIT PHOTOGRAPHERS

Christopher Grey shows you how to master traditional lighting styles and use creative modifications to maximize your results. *$34.95 list, 8.5x11, 128p, 300 color photos, index, order no. 1778.*

The Best of Wedding Photography, 3rd Ed.

Bill Hurter shows you how top photographers transform special moments into lasting romantic treasures. *$39.95 list, 8.5x11, 128p, 200 color photos, order no. 1837.*

Existing Light TECHNIQUES FOR
WEDDING AND PORTRAIT PHOTOGRAPHY

Bill Hurter and a host of pros show you how to work with window, outdoor, fluorescent, and incandescent light. *$34.95 list, 8.5x11, 128p, 150 color photos, index, order no. 1858.*

500 Poses for Photographing Women

Michelle Perkins compiles an array of striking poses, from head-and-shoulders to full-length, for classic and modern images. *$34.95 list, 8.5x11, 128p, 500 color images, order no. 1879.*

Minimalist Lighting

PROFESSIONAL TECHNIQUES FOR STUDIO PHOTOGRAPHY

Kirk Tuck provides tips for setting up a studio with minimal gear. *$34.95 list, 8.5x11, 128p, 190 color images and diagrams, index, order no. 1880.*

Master Posing Guide for Wedding Photographers

Bill Hurter shows you posing ideas that make your clients look their best and capture the joy of the event. *$34.95 list, 8.5x11, 128p, 180 color images and diagrams, index, order no. 1881.*

ELLIE VAYO'S GUIDE TO
Boudoir Photography

Learn how to create flattering, sensual images of women. Covers everything from the consultation to the sale. *$34.95 list, 8.5x11, 128p, 180 color images, index, order no. 1882.*

MASTER GUIDE FOR **Photographing High School Seniors**

Dave, Jean, and J. D. Wacker show you how to stay at the top of the senior portrait market. *$34.95 list, 8.5x11, 128p, 270 color images, index, order no. 1883.*

Available Light PHOTOGRAPHIC

TECHNIQUES FOR USING EXISTING LIGHT SOURCES

Don Marr shows you how to find great light, modify not-so-great light, and harness the beauty of some unusual light sources. *$34.95 list, 8.5x11, 128p, 135 color images, index, order no. 1885.*

JEFF SMITH'S GUIDE TO
Head and Shoulders Portrait Photography

Make head and shoulders portraits a more creative and lucrative part of your business. *$34.95 list, 8.5x11, 128p, 200 color images, index, order no. 1886.*

JEFF SMITH'S **Senior Portrait Photography Handbook**

Improve your images and profitability through better design, market analysis, and business practices. *$34.95 list, 8.5x11, 128p, 170 color images, index, order no. 1896.*

Off-Camera Flash CREATIVE

TECHNIQUES FOR DIGITAL PHOTOGRAPHERS

Rod and Robin Deutschmann show you how to add off-camera flash to your repertoire and maximize your creativity. *$34.95 list, 8.5x11, 128p, 269 color images, 41 diagrams, index, order no. 1913.*

Photographic Lighting Equipment

Kirk Tuck teaches you how to build the best lighting arsenal for your specific needs. *$34.95 list, 8.5x11, 128p, 350 color images, 20 diagrams, index, order no. 1914.*

Advanced Wedding Photojournalism

Tracy Dorr shows you how to tune in to the day's events and participants so you can capture beautiful, emotional images. *$34.95 list, 8.5x11, 128p, 200 color images, index, order no. 1915.*

Corrective Lighting, Posing & Retouching FOR DIGITAL PORTRAIT

PHOTOGRAPHERS, 3RD ED.

Jeff Smith shows you how to address and resolve your subject's perceived flaws. *$34.95 list, 8.5x11, 128p, 180 color images, index, order no. 1916.*

TUCCI AND USMANI'S
The Business of Photography

Take your business from flat to fantastic using the foundational business and marketing strategies detailed in this book. *$34.95 list, 8.5x11, 128p, 180 color images, index, order no. 1919.*

CHRISTOPHER GREY'S
Advanced Lighting Techniques

Learn how to create stylized lighting effects that other studios can't touch with this witty, informative guide. *$34.95 list, 8.5x11, 128p, 200 color images, 26 diagrams, index, order no. 1920.*

Engagement Portraiture

Tracy Dorr demonstrates how to create masterful engagement portraits and build a marketing and sales approach that maximizes profits. *$34.95 list, 8.5x11, 128p, 200 color images, index, order no. 1946.*

Lighting Essentials

Don Giannatti's subject-centric approach to lighting will teach you how to make confident lighting choices and flawlessly execute images that match your creative vision. *$34.95 list, 8.5x11, 128p, 240 color images, index, order no. 1947.*

Painting with a Lens

Set your camera in manual mode and use techniques like "ripping," "punching," and the "flutter" to create painterly, moody images. *$34.95 list, 8.5x11, 128p, 170 color images, order no. 1948.*

The Portrait Photographer's Guide to Posing, 2nd Ed.

Bill Hurter calls upon industry pros who show you the posing techniques that have taken them to the top. $34.95 list, 8.5x11, 128p, 250 color images, 5 diagrams, index, order no. 1949.

The Art of Off-Camera Flash Photography

Lou Jacobs Jr. provides a look at the lighting strategies of ten portrait and commercial lighting pros. *$34.95 list, 8.5x11, 128p, 180 color images, 30 diagrams, index, order no. 2008.*

Advanced Underwater Photography

Larry Gates shows you how to take your underwater photography to the next level and care for your equipment. *$34.95 list, 8.5x11, 128p, 225 color images, index, order no. 1951.*

Boutique Baby Photography

Create the ultimate portrait experience—from start to finish—for your higher-end baby and maternity portrait clients and watch your profits grow. *$34.95 list, 7.5x10, 160p, 200 color images, index, order no. 1952.*

Behind the Shutter

Salvatore Cincotta shares the business and marketing information you need to build a thriving wedding photography business. *$34.95 list, 7.5x10, 160p, 230 color images, index, order no. 1953.*

Studio Lighting Unplugged

Rod and Robin Deutschmann show you how to use versatile, portable small flash to set up a studio and create high-quality studio lighting effects in *any* location. *$34.95 list, 7.5x10, 160p, 300 color images, index, order no. 1954.*

Master's Guide to Off-Camera Flash

Barry Staver presents basic principals of good lighting and shows you how to apply them with flash, both on and off the camera. $34.95 list, 7.5x10, 160p, 190 color images, index, order no. 1950.

THE DIGITAL PHOTOGRAPHER'S GUIDE TO
Light Modifiers SCULPTING WITH LIGHT™

Allison Earnest shows you how to use an array of light modifiers to enhance your studio and location images. *$34.95 list, 8.5x11, 128p, 190 color images, 30 diagrams, index, order no. 1921.*

JOE FARACE'S
Glamour Photography

Contains ideas for connecting with models, building portfolios, selecting locations, and more. *$34.95 list, 8.5x11, 128p, 180 color images, 20 diagrams, index, order no. 1922.*

Multiple Flash Photography

Rod and Robin Deutschmann show you how to use two, three, and four off-camera flash units and modifiers to create artistic images. *$34.95 list, 8.5x11, 128p, 180 color images, 30 diagrams, index, order no. 1923.*

CHRISTOPHER GREY'S
Lighting Techniques
FOR BEAUTY AND GLAMOUR PHOTOGRAPHY

Use twenty-six setups to create elegant and edgy lighting. *$34.95 list, 8.5x11, 128p, 170 color images, 30 diagrams, index, order no. 1924.*

UNLEASHING THE RAW POWER OF
Adobe® Camera Raw®

Mark Chen teaches you how to perfect your files for unprecedented results. *$34.95 list, 8.5x11, 128p, 100 color images, 100 screen shots, index, order no. 1925.*

500 Poses for Photographing Brides

Michelle Perkins showcases an array of head-and-shoulders, three-quarter, full-length, and seated and standing poses. *$34.95 list, 8.5x11, 128p, 500 color images, index, order no. 1909.*

Understanding and Controlling Strobe Lighting

John Siskin shows you how to use and modify a single strobe, balance lights, perfect exposure, and more. *$34.95 list, 8.5x11, 128p, 150 color images, 20 diagrams, index, order no. 1927.*

JEFF SMITH'S
Studio Flash Photography

This common-sense approach to strobe lighting shows photographers how to tailor their setups to each individual subject. *$34.95 list, 8.5x11, 128p, 150 color images, index, order no. 1928.*

Just One Flash

Rod and Robin Deutschmann show you how to get back to the basics and create striking photos with just one flash. *$34.95 list, 8.5x11, 128p, 180 color images, 30 diagrams, index, order no. 1929.*

WES KRONINGER'S
Lighting Design Techniques
FOR DIGITAL PHOTOGRAPHERS

Create setups that blur the lines between fashion, editorial, and classic portraits. *$34.95 list, 8.5x11, 128p, 80 color images, 60 diagrams, index, order no. 1930.*

DOUG BOX'S
Flash Photography

Doug Box helps you master the use of flash to create perfect portrait, wedding, and event shots anywhere. *$34.95 list, 8.5x11, 128p, 345 color images, index, order no. 1931.*

500 Poses for Photographing Men

Michelle Perkins showcases an array of head-and-shoulders, three-quarter, full-length, and seated and standing poses. *$34.95 list, 8.5x11, 128p, 500 color images, order no. 1934.*

Off-Camera Flash
TECHNIQUES FOR DIGITAL PHOTOGRAPHERS

Neil van Niekerk shows you how to set your camera, choose the right settings, and position your flash for exceptional results. *$34.95 list, 8.5x11, 128p, 235 color images, index, order no. 1935.*

Wedding Photojournalism
THE BUSINESS OF AESTHETICS

Paul D. Van Hoy II shows you how to create strong images, implement smart business and marketing practices, and more. *$34.95 list, 8.5x11, 128p, 230 color images, index, order no. 1939.*

THE DIGITAL PHOTOGRAPHER'S GUIDE TO
Natural-Light Family Portraits

Jennifer George teaches you how to use natural light and meaningful locations to create cherished portraits and bigger sales. *$34.95 list, 8.5x11, 128p, 180 color images, index, order no. 1937.*

BILL HURTER'S
Small Flash Photography

Learn to select and place small flash units, choose proper flash settings and communication, and more. *$34.95 list, 8.5x11, 128p, 180 color photos and diagrams, index, order no. 1936.*

Family Photography

Christie Mumm shows you how to build a business based on client relationships and capture life-cycle milestones, from births, to senior portraits, to weddings. *$34.95 list, 8.5x11, 128p, 220 color images, index, order no. 1941.*

Nikon® Speedlight® Handbook

Stephanie Zettl gets down and dirty with this dynamic lighting system, showing you how to maximize your results in the studio or on location. *$34.95 list, 7.5x10, 160p, 300 color images, order no. 1959.*